The Garden of Earthly Delights

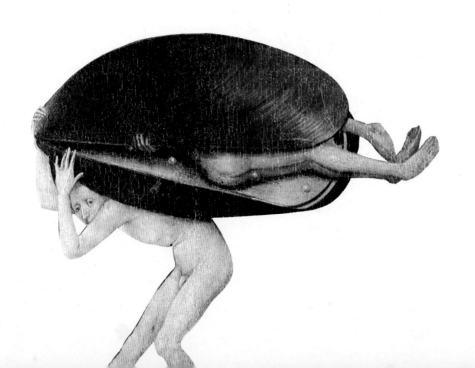

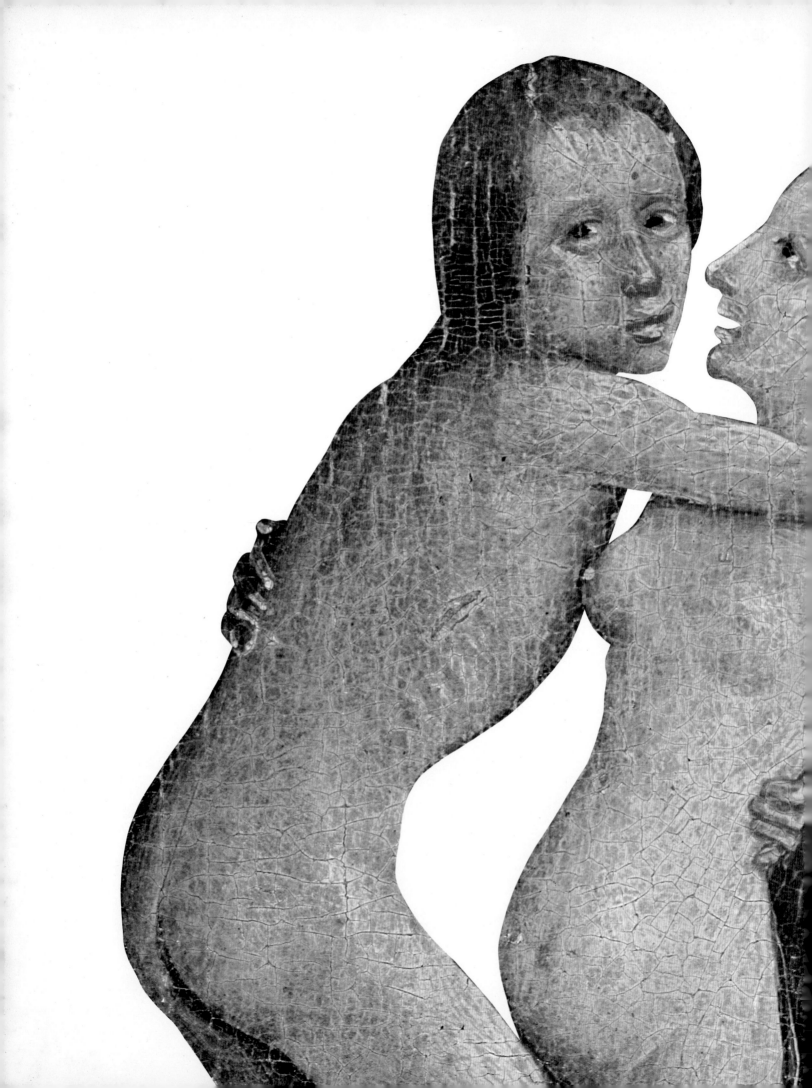

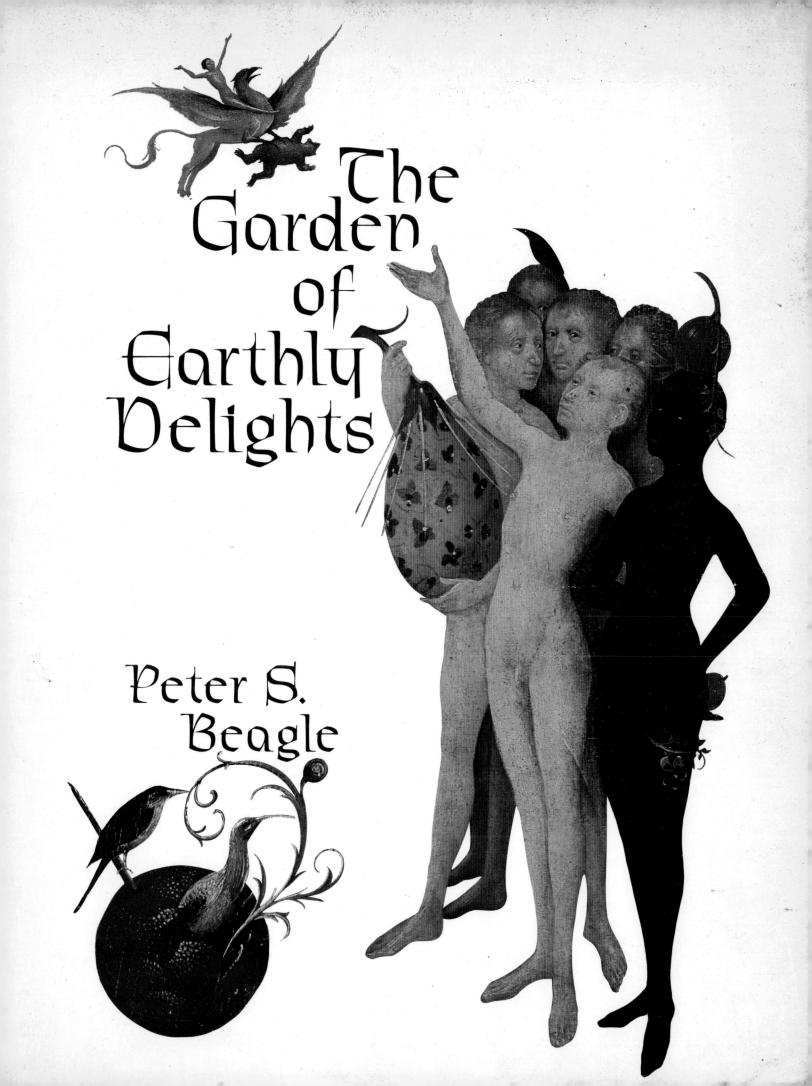

The Garden of Earthly Delights

Peter S. Beagle

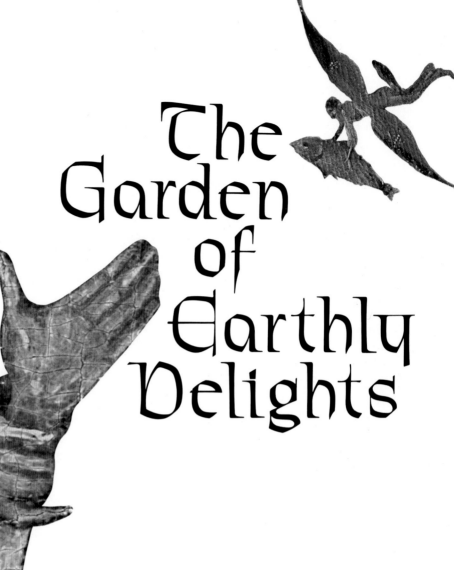

The Garden of Earthly Delights

by
Peter S. Beagle

PICADOR

Published by Pan Books

First published in the USA 1982
by The Viking Press (A Studio Book)
This Picador edition first published
in Great Britain 1982 by Pan Books Ltd.,
Cavaye Place, London SW10 9PG

Copyright © 1982 by Peter S. Beagle
and Knapp Communications Corporation
Produced for The Viking Press by

Rosebud Books,
a division of The Knapp Press.

Book design by Laura LiPuma

ISBN 0-330-26716-7

For Colleen J. McElroy

Acknowledgements

Over the course of two years, a small band of dedicated
loonies has been essential to the creation of this book. I would like to
thank each of these gracious souls who so patiently
endured intense, prolonged encounters with Boschian demons and
delights in order to bring them to life for the reader. My
thanks go to Donald Ackland of Rosebud Books, who provided the
original inspiration and impetus for this volume; to Dr.
Burr Wallen of the University of California at Santa Barbara for his sure
counsel on scholarly points throughout the book, and
his important role in the shaping of the later chapters; to Annette Leddy,
whose research and writing formed the basis of the post-
essay chapters; to Laura LiPuma for her imaginative and vital design; and,
finally, to supervising editor Jeffrey Book, who
coordinated and wove together the diverse strands of this work. It is an
appalling cliché to say that I couldn't have done it
without them; and absolutely true.

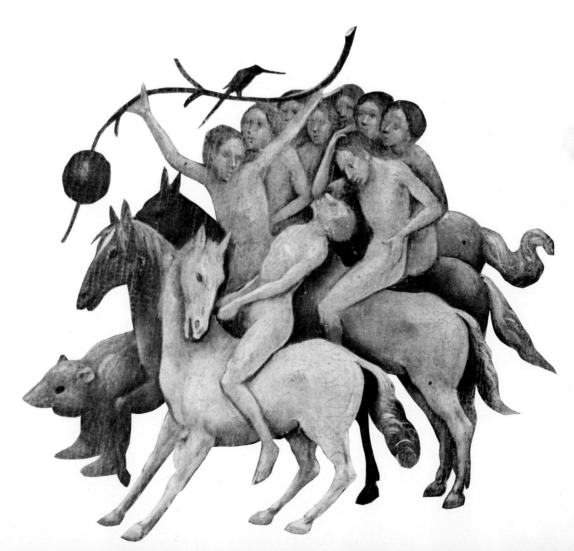

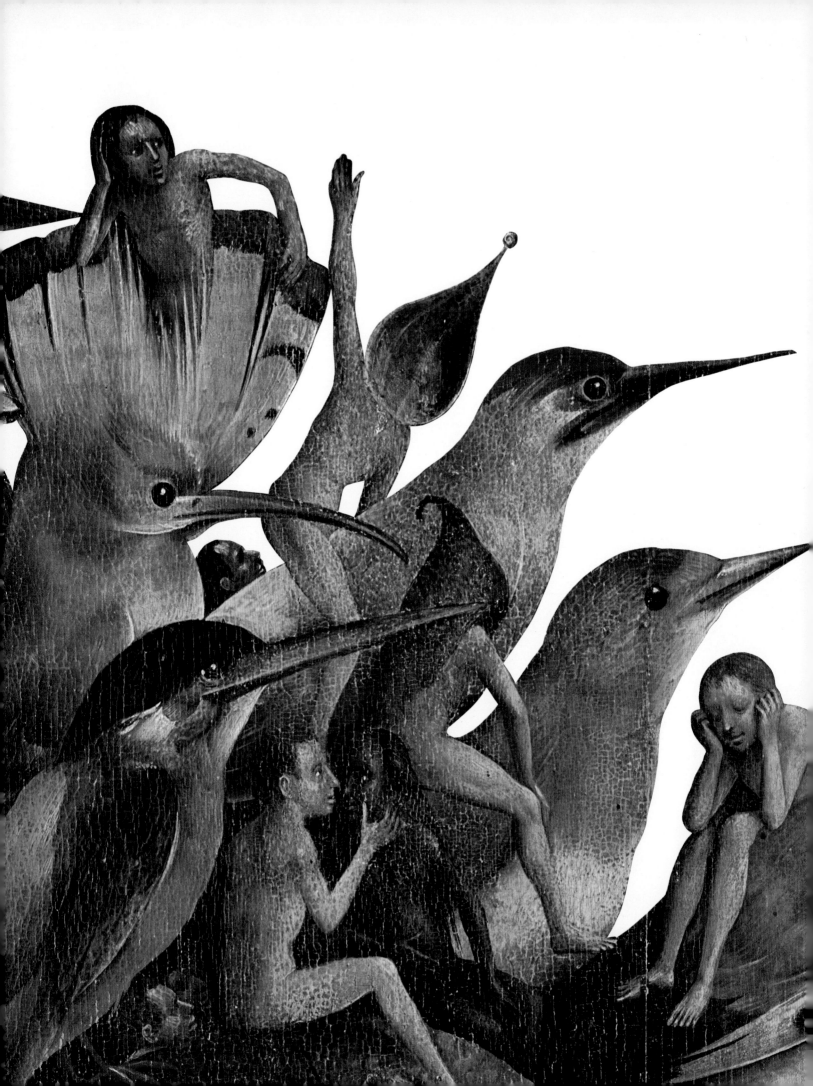

CONTENTS

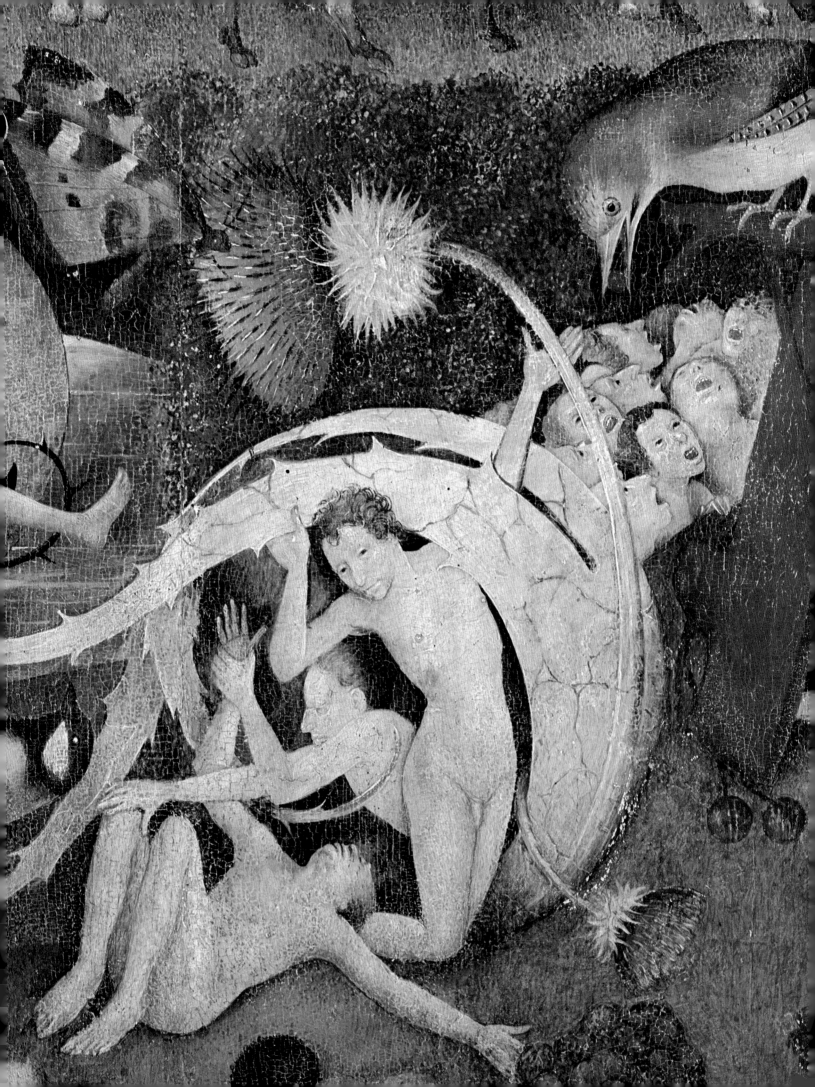

1
The Garden of Earthly Delights

There are also some panels of various strange scenes, simulating . . . things which are so pleasing and fantastic that it would be impossible to describe them properly to those who have no knowledge of them.
Antonio de Beatis, describing "The Garden of Earthly Delights" in 1517

Towards the end of the Middle Ages two factors dominate religious life: the extreme saturation of the religious atmosphere, and a marked tendency of thought to embody itself in images.
Johan Huizinga, *The Waning of the Middle Ages*, 1924

To begin properly, then, with an image: writing anything at all about Hieronymus Bosch—even the single paragraph that will fairly summarize what we truly know of his life—is like going to sea in a leaky boat. It will float, after a fashion, or at least not sink completely; but waves of Speculation will flood over its decks, the galley slaves of Logic, Deduction and Evidence will be overworked to the point of mutiny, and the happy port of Certainty will be very little closer. We will, at best, merely have been for a picnic outing in the good Ship of Fools.

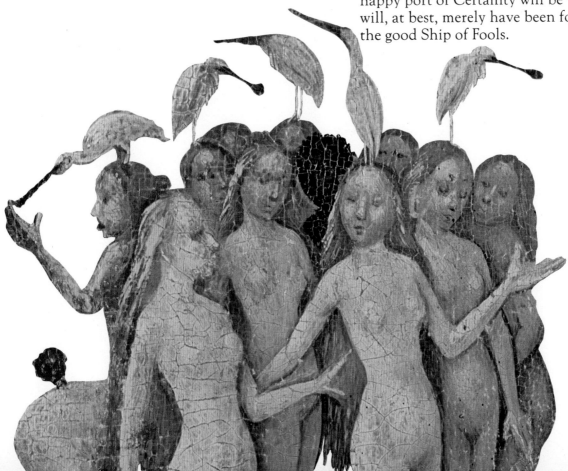

Details from
The Garden of Earthly Delights,
center panel.

His real name was Jeroen Anthoniszoon van Aken. He was born around 1450 in 's-Hertogenbosch, a thriving Netherlandish commercial town in northern Brabant. His grandfather, his father, his brother, and at least three uncles were also painters. Sometime between 1475 and 1481 he married Aleyt van den Meervenne, the daughter of a wealthy burgher; and in 1486 he was registered as a member of the Lieve-Vrouwe Broederschap (Brotherhood of Our Lady), in which he became a "notable" two years later. We learn from the Brotherhood's records that he apparently painted a scene of *Abigail before David* on the wings of their altarpiece in the great 's-Hertogenbosch Cathedral of St. John, where a *Crucifixion* fresco attributed to his grandfather, Jan van Aken, survives. In 1492 he designed a stained-glass window for the Brotherhood's own chapel. Philip the Fair, Archduke of Austria, commissioned a *Last Judgment* from him in 1504. Between 1508 and 1512 we find him designing a chandelier as well as a crucifix for the Brotherhood, and checking the gilding and coloring of the altarpiece. He died in late July or early August of 1516, and the notices of his death referred to him as a *"seer vermaerd schilder"* (very famous painter). And that—except for the occasional appearances of his name in city records and Brotherhood annals—is it for the documentation.

> . . . *in real life he was quite an ordinary fellow I'm told, a city father who enjoyed taking care of the costumes of the yearly carnival, the religious carnival. Of course everything was religious then.*
>
> Dutch novelist Janwillem van de Wetering, in a letter to the author, 2/19/80

This is, beyond any doubt, the only art book I will ever write. Like Bosch, I come from a family of painters; in mine, however, I am the only one who cannot draw. I cannot draw *anything*—not a house with smoke coming from the chimney, not a cow in a field, not the way to my house (I'll write the directions out in great detail, sooner than draw them), not a simple landscape with sprawled V's for flying birds, not a straight line. I joke about it now, and say that I was forced into becoming a writer to express in words the things I couldn't say with my hands; but I cried then. I wanted to draw a stuffed moose in the Museum of Natural History, and I still do, and I can't.

Worse than that, as I grew older, was the feeling that I was also the only one in my family who didn't know how to look at art. Having become fatally addicted to language, to story, to the inexhaustible sensuality of words and the sinful chocolate pleasure of making things up, I seemed somehow to have mislaid my eyes. I went to museums and memorized names; I posed for my uncles and my best friend, and learned about white lead, canvas-stretching, and rabbit-skin glue; and I picked up a fair store of useful phrases like "plastic values" and "spatiotemporal relationships" from people overheard at parties. To invert the cliché, I actually did know something about art, but nothing at all about what I liked, and to one degree or another it has continued so. Much of the time I still feel graphically tone-deaf, as far away as ever from understanding where a painting begins and ends, and why artists make the choices that they make. I am capable of loving paintings, but rarely of seeing them. Unfortunately, I know the difference.

So why should he speak to me, that crazy Dutchman, Fleming, German, whatever he was? Why should I respond to Bosch's visions of damnation, somewhere in myself, when—as a modern, skeptical, secular Jew—I'd believe in acupuncture and orgone therapy before an afterlife? When, more than anything in the world, I dread and loathe the brutal, hysterical religiosity from which these paintings spring: the fanatic righteousness that invented hell because heaven meant getting to watch your neighbors suffer forever? That old man in the self-portrait with his reptilian mouth and his grim stare glittering across five hundred years—why should his work have mattered so strangely to me for so long? Why should I feel that I know him?

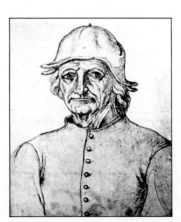

Presumed later copy (ca. 1550) of a Bosch self-portrait. Arras, Bibliothèque Municipale d'Arras.

For one thing, I found him by myself. I don't recall ever being taken to any museum to see his work exhibited; nor did my high school art-appreciation classes discuss him in their one-week surveys of the "Flemish primitives." My uncles, New York realists, spoke of their heroes—Rembrandt, Corot, Degas—and of their friends and contemporaries—Hopper, Eakins, Grosz, Blume, Levine—and they would surely have told me about Bosch if I had even known his name to ask them. But I discovered him (adulterated, of course, like any powerful drug) on the covers of the science-fiction books and magazines that I read so omnivorously as a boy. In the same way that Hollywood film composers have traditionally pillaged Tchaikovsky, many of the old pulp illustrators plainly turned to Bosch for public-domain inspiration. His nameless monsters converted easily into properly horrifying aliens; his smoldering wastelands and his remote, transparent skies suggest *Thrilling Wonder Stories'* idea of Mars at least as much as they do Brabant. I remember only Bantam Books as ever giving credit, for a fragment of *The Garden of Earthly Delights* which was used on the jacket of Fredric Brown's short-story collection, *Honeymoon in Hell.* That was the first time I ever heard of that painting, or of Hieronymus Bosch.

What attracted me first and most fiercely, as it does still, was the immediacy of his images—the shock lying not so much in what he painted, as in its uncanny, impossible familiarity. Granted that I was a boy already intoxicated with fantasy, earnestly collecting nightmares instead of coins or autographs; granted, too, that Bosch was unique in his ability to extend the traditional Flemish love of minute detail into the fiery darkness of the popular

Detail from *The Haywain*, right panel.

imagination—even so, I wonder yet why I should have *recognized* that owl-headed, double-bodied juggler of cherries, that beaked demon gulping down the crow-farting damned. Bosch seemed to me to be drawing his monstrously beautiful creatures from life, matter-of-factly lining up all hell to sit for him, as brisk a realist as my uncles. *There is no such place, but this is how it must be. How did he know—and how do I?*

One reason, at least, seems terribly obvious. I was growing up in the years just after World War II, in the time when the Holocaust had no name because the fact of what had happened to the Jews of Europe was still too much for language to absorb. That fact was joined by another, this one almost nothing but a name, learned with my own: Hiroshima. Having learned of these horrendous events at an early age, it is hard for me to remember a time when I did not know, as simply as I knew that Joe DiMaggio was the best baseball player in the world, that there is nothing—nothing—that human beings will not do to one another, for the pure pleasure of it, and that their evil will neither be prevented in this world nor punished in the next. The Nazis may or may not have lost a war, but their howl of triumph still

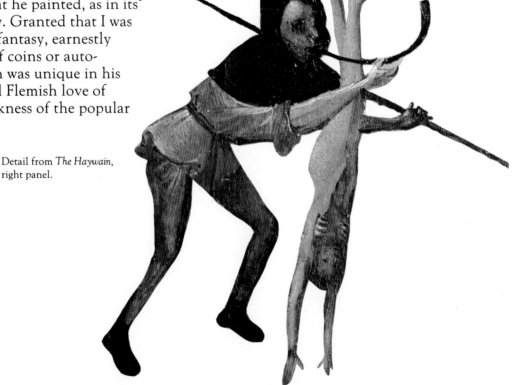

echoes everywhere, every minute. *Nothing is forbidden, there is no covenant. The lightning does not come.* Civilization has always flourished in the shadow of this knowledge, and our own culture has even trained itself to climb it, like a morning-glory vine. We call it "the existential dilemma," and "the human condition," but Hieronymus Bosch's world called it the Devil.

The parallels between that world and our own grow increasingly striking as we are spun blindfolded into the 1980s. European society in the late Middle Ages may not have had to deal with its own power to destroy the earth itself, but it believed fervently in a Wrath which was forever on the verge of doing just that. If—as it sometimes seems—to eat and drink and breathe in our time means to be

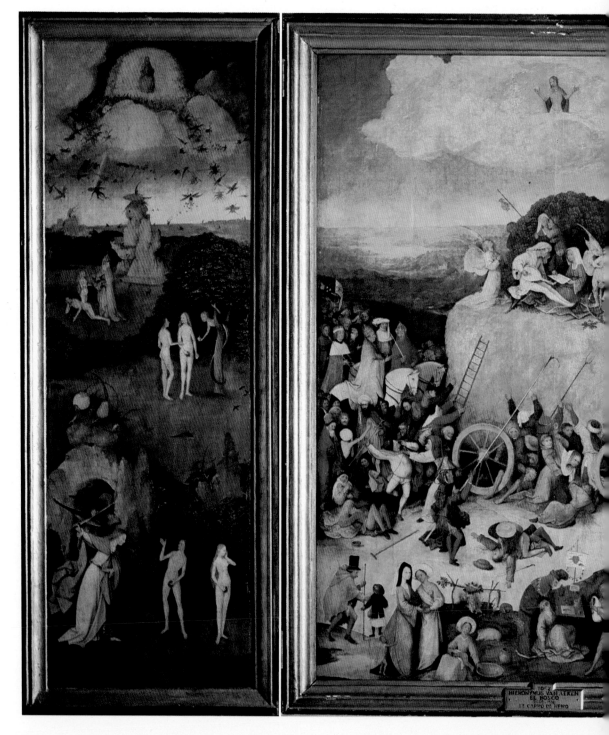

helplessly inviting cancer from the day of one's birth, Bosch's time lived with the equally random ravaging of the Black Plague; if we are faced with the constant threat of war scampering like fire all through the Middle East or Central America, the fifteenth century endured the last ruinous battles of the Hundred Years' War and the first onslaughts of the Turks. (Bosch's birth, in fact, coincides almost exactly with the devastating fall of Constantinople.) The motiveless, spontaneous violence that is tacitly becoming an accepted condition of Western life would have been quite familiar to a citizen of 's-Hertogenbosch—he might only have been surprised at the shortage of scaffolds and gibbets, and the remarkable abundance of prisons. To quote Johan Huizinga again:

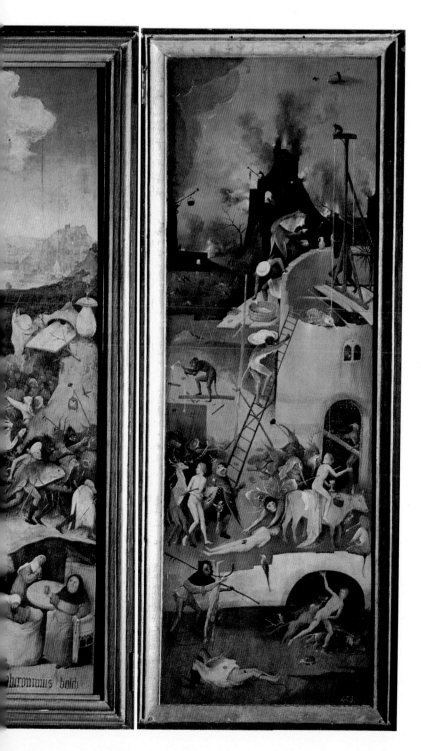

A general feeling of impending calamity hangs over all. Perpetual danger prevails everywhere. . . . The feeling of general insecurity which was caused by the chronic forms wars were apt to take, by the constant menace of the dangerous classes, by the mistrust of justice, was further aggravated by the obsession of the coming end of the world, and by the fear of hell, of sorcerers and of devils. . . . Everywhere the flames of hatred arise and injustice reigns. Satan covers a gloomy earth with his somber wings.

The *Haywain* triptych.
Madrid, Museo del Prado.

An order of things was coming unravelled when Bosch was born. The savage security of feudalism had lain in a general understanding that the system mirrored—indeed, was an extension of—the order of things in heaven. God the Father, the Grand Seigneur, held the world in fief, parcelling lands and powers out to his great vassals, the popes and emperors and kings, who sublet in their turn; he maintained celestial armies, as they did on earth; fought campaigns and prepared for mightier ones; revealed his purposes only to a very few trusted agents, took the same pleasure as any mortal king in homage, feats, fabulous panoply, gargantuan celebrations, and the granting of splendid gifts (along with the exacting of properly pitiless vengeances). And as the earthly hierarchy was seen to be an imperfect emulation of the heavenly, so medieval man, whatever his station in life, was entitled to regard himself as personally necessary to some immense Fulfillment, constantly spinning reverence

and revelation into his daily life. Knight, cleric or serf, to serve his appointed master was to be serving God, like the earthly counterpart of some attendant angel; and God knew that, if his master did not. There would be an indescribably wondrous reward for all such servants one day: it had been promised, and God kept his word. Unlike most temporal monarchs, he obeyed his own laws.

But by the middle of the fifteenth century, these certainties and every other were as much under siege as God himself seemed to be. The Devil (originally very much a creature of the church, intended both to absorb the last remnants of pre-Christian paganism, and to account for the horrible cruelties and injustices that could not so easily be explained away as heaven's will), was steadily coming to be regarded as the Lord here below, plainly far stronger than God, and far more candid and precise about his own desires, and those of human beings. *Come, consider— if God cannot protect his flock in this life, what price all his promises of living again in glory? I ask so little of you—merely that you look long around you at the world, and at yourselves in it, and then tell me which of us is the Father of Lies.*

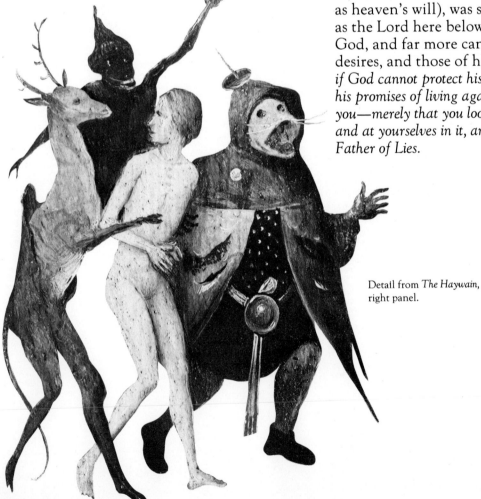

Detail from *The Haywain*, right panel.

Bosch's civilization was as haunted by fears that men's souls might be doomed after all as ours is by the disquieting suspicion of something in us that will not improve, that resists evolution. Obsessed by the dread of physical death as no epoch had been before—nor has been since, until our own—the popular mind of 1450 saw in putrefaction the ultimate triumph of Satan; as we see it in terrorism, in the price of oil, and in the growing knowledge that we live our lives only at the sufferance of the armed psychopaths among us. The idea of human progress, the belief that things get better, has served most of us as a church for a long time: it is certainly the faith in which I was raised. Perhaps we are closer to Bosch's neighbors than we imagine in wondering whether the insane, chaotic tumult that increasingly fills our days and nights might not be the clumping of a god hastily packing his bags in the dusty attic.

Is it surprising then, or coincidental, that Bosch's artistic reputation clearly seems to have been at its highest in his own time and ours? Like his one great disciple, Pieter Bruegel, Bosch vanishes almost entirely from critical consideration for more than three centuries, during which such eminences as Sir Joshua Reynolds and John Ruskin hardly mention him. He had nothing to say, in terms of subject matter or technique, that the Baroque painters, the Classicists or the Neo-Classicists wanted to hear; and if the Romantic movement, with its emphasis on natural human goodness corrupted by modern industrial society, ever studied Hieronymus Bosch at all, he must have made its theoreticians extremely uncomfortable. It took the twentieth century to rediscover his work—most of the important studies, in fact, have appeared within the last forty years—and to appreciate it, if not quite with the grimly eager literalness of Philip II (who had Bosch's *The Seven Deadly Sins* hung in his bedroom at the Escorial), then with the sad fascination and curiosity befitting a culture that is being forced to acknowledge the demonic in itself. The consumer culture will try to defang and absorb Bosch's demons, applying them to jigsaw puzzles and children's lunch boxes, but it won't be easy. Beyond pop culture, beyond futile Freudian theorizing, beyond all speculation about his life, his associations, his sexuality, his private codes, the crucial fact remains: the man meant what he painted.

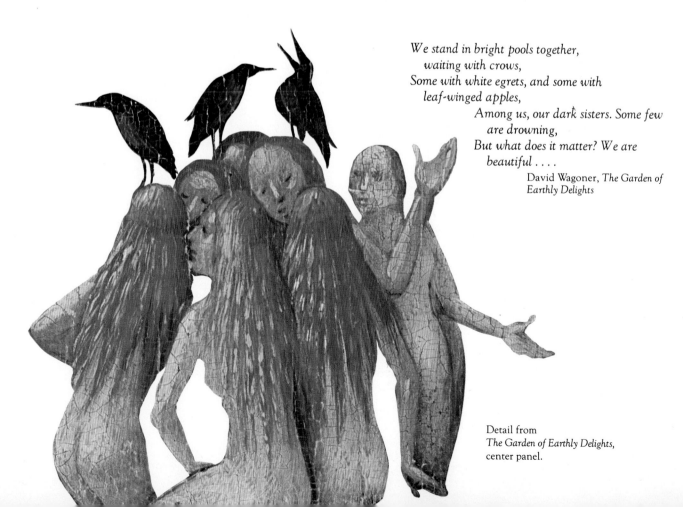

We stand in bright pools together,
 waiting with crows,
Some with white egrets, and some with
 leaf-winged apples,
 Among us, our dark sisters. Some few
 are drowning,
 But what does it matter? We are
 beautiful

David Wagoner, *The Garden of Earthly Delights*

Detail from
The Garden of Earthly Delights,
center panel.

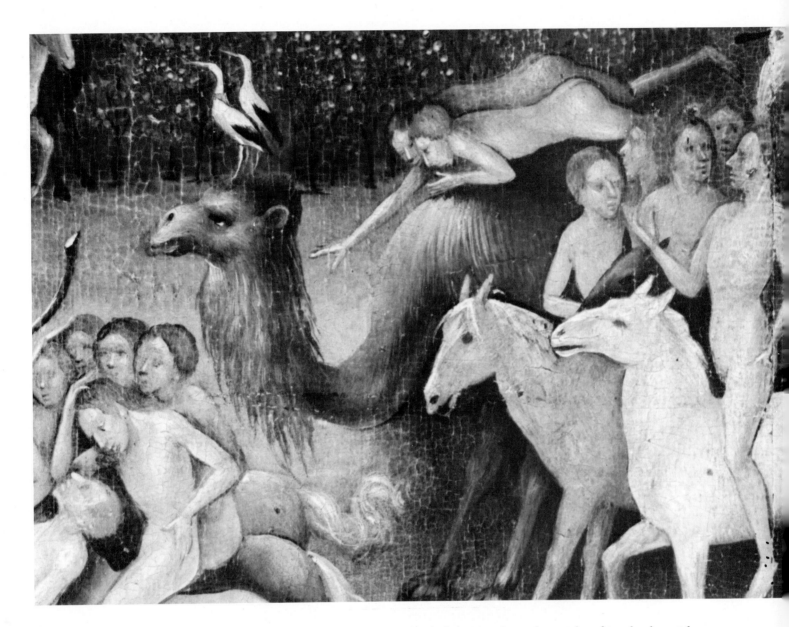

And that was the other side of it, the horrid, seething loveliness of the work itself. I am not speaking—even if I could—of Bosch's technical achievement in color and composition, in the use of movement and space; what drew me, at thirteen, deeper and deeper into his universe was the astonishingly delicate, almost innocent beauty of those sinful men and women, those half-monsters, those demons, as well as of the *acts*, those phosphorescently awful things that were going on in all corners of *The Haywain, The Temptation of St. Anthony, The Garden of Earthly Delights* and *The Last*

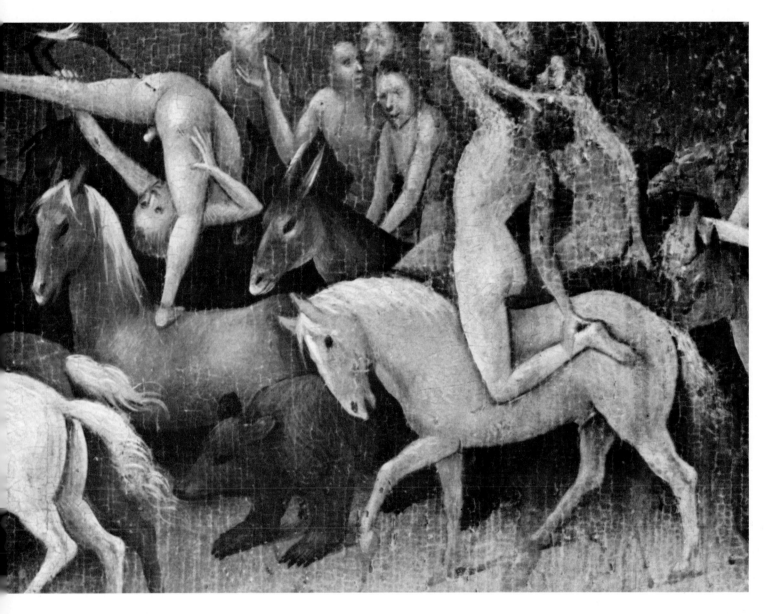

Judgment. Patiently hunting out the dirty parts and the scary scenes, I prowled through the triptychs, marvelling that They would ever allow you to publish a picture of a man with something like that sticking out of his ass, or of whatever that other one somersaulting on horseback was really trying to do to himself. But adolescent prurience wore off quickly, and the titillation of horror also faded, as will happen in a world where nothing is unthinkable. What remained was beauty and mystery, and a strange sense of love.

Details from
The Garden of Earthly Delights,
center panel.

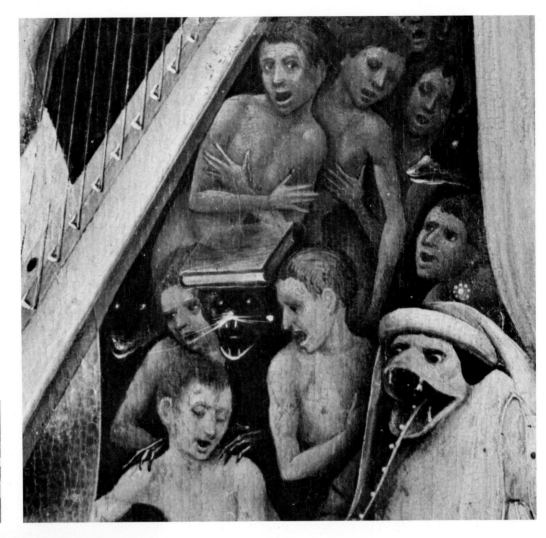

Details from
The Garden of Earthly Delights,
right panel.

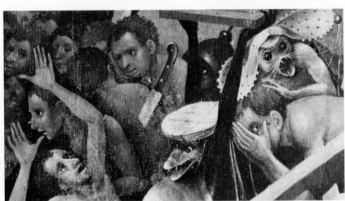

Maybe *tenderness* is the word I want. Almost nowhere in Bosch's comparatively naturalistic paintings, from the early *The Cure of Folly* and *The Conjuror* to *Christ before Pilate, The Crowning with Thorns,* and *Christ Carrying the Cross,* is there any sense of affection, of the least sympathy for his subjects. Except for the passive, sleepwalking figure of Christ, the panels are charged with uniformly gross and lumpish bodies, and faces either woodenly vacant, blindly covetous, or absolutely transcendent with hatred. The great majority appear to be members of the merchant class and the clergy, people who would certainly consider themselves vastly more virtuous than the swarming sinners of *The Haywain* or *The Last Judgment.* But their malevolence far surpasses that of Bosch's demons, because they look like human beings, and their pleasure in their own cruelty is a human pleasure. Whatever Bosch truly felt about the beautiful damned souls of his garden, he hated these others.

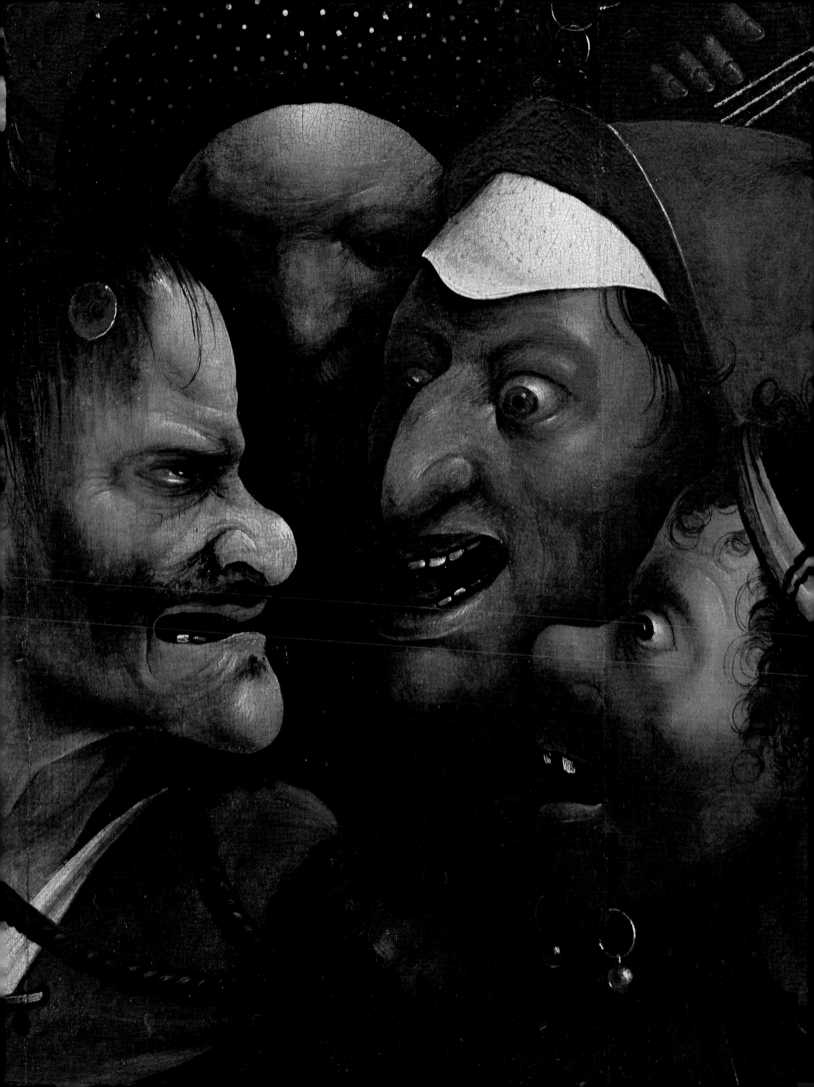

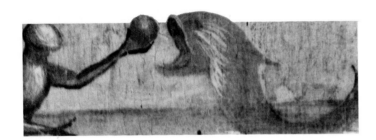

The Garden of Earthly Delights was a great success at the court of Philip II, where Bosch was much approved of for his savage moralizing, his curious wit, his didacticism, and his apparent indictments of heresy and witchcraft. The king's knowledgeable spiritual counselor, Fray José de Sigüenza, praises the triptych as a powerful work of deep wisdom, worthy of close study. Behind the *Garden*'s seemingly absurd fantasies he saw cached countless mystical warnings about the eternal dangers that beset the human soul—a subject of particular concern to the passionate Counter-Reformation theologian. Fray Sigüenza seems to have regarded that particular painting as something perilously close to sorcery itself.

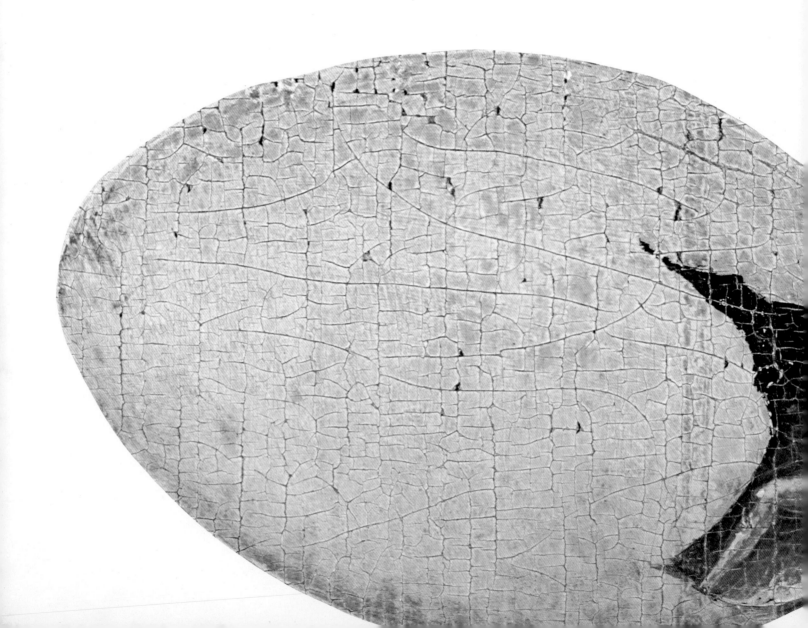

But I wonder what Alonso Pérez de Gúzman, duke of Medina-Sidonia, thought of it. The duke of Medina-Sidonia is my favorite Spanish aristocrat ever, except possibly for his notorious descendant, the "Red Duchess" of our own era who joined the coal miners in Asturias in strikes and demonstrations against Franco, and went to prison for it. He was a mild, retiring, sensible man who made sherry and was appointed admiral of the Armada by Philip, in spite of the fact that he got seasick on a duck pond. The duke knew that the invasion of England would be a complete disaster, and that Philip would blame him for it, and told the king as much in a series of earnestly courageous letters. He was right on both counts, but survived anyway.

I wonder if the duke of Medina-Sidonia, who came to court very rarely, ever saw *The Garden of Earthly Delights*; and if he allowed himself to notice for a moment the ineradicable grace of all those egg-naked condemned? No matter what they do in the Garden, they remain beautiful, curious children; no matter what specific sins Bosch intended them to represent and animate, he treats them with a kind of terrible compassion that is unique in his work. And whatever is done to them by his toiling demons, they remain so humanly appealing that at last the effect is of a collective Christ, suffering as meaninglessly as all humankind suffers, yet never without meaning, even in hell. It is no accident that their beauty endures.

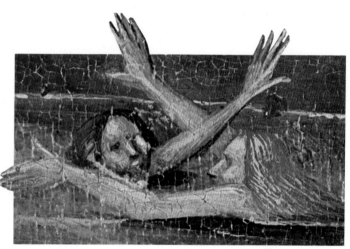

Details from
The Garden of Earthly Delights,
center panel.

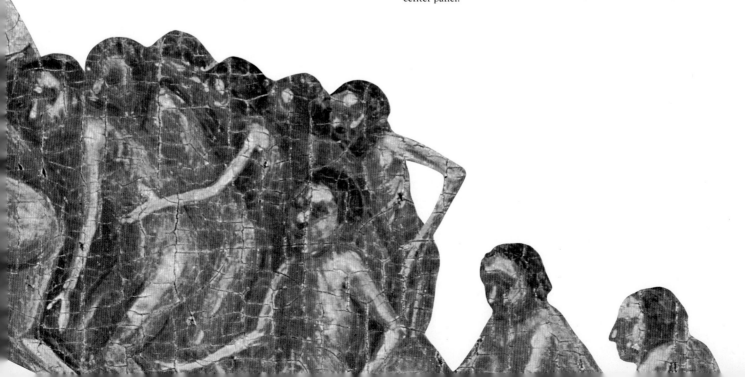

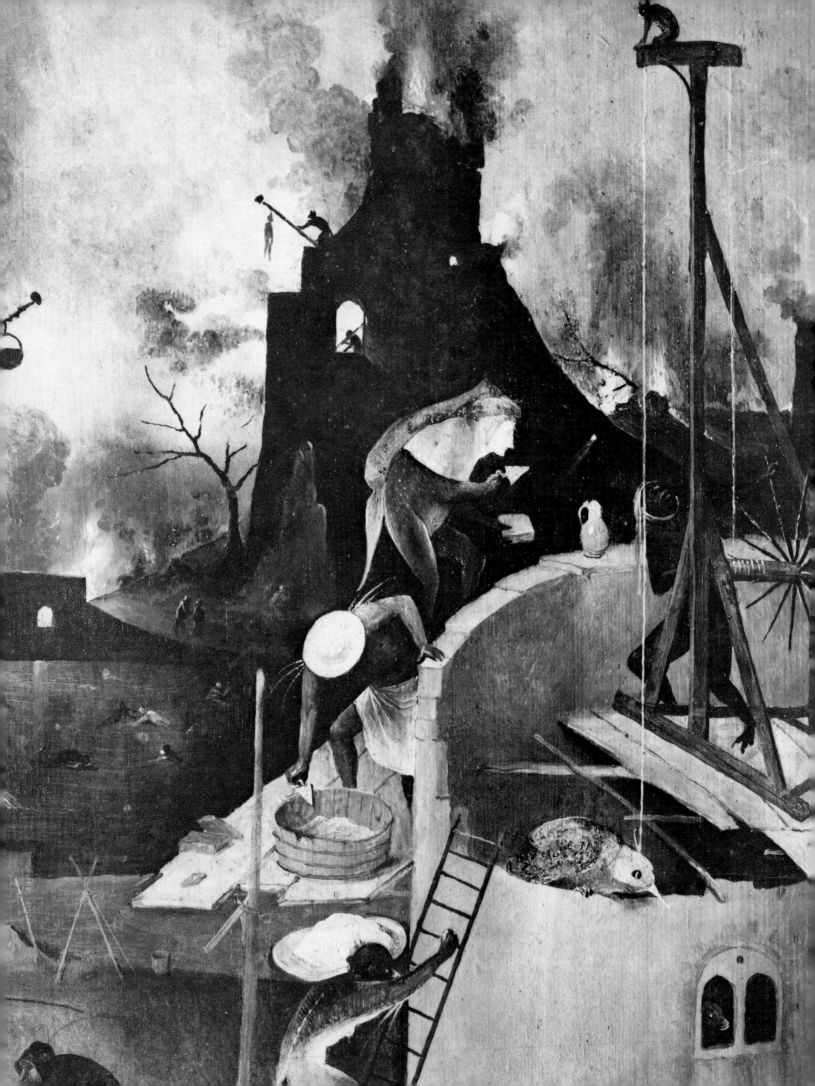

I wonder too if the sensible duke would have observed how sad they all seem in the midst of their sensual paradise. If they are always lovely, they are never joyous, not for a moment; their erotic freedom finally touches them no more than will the grotesque agonies that await them. David Wagoner's poem concludes:

> . . . we will stay here and become
> nothing
> But what we are, the careless gardeners
> Who scarcely touch the earth, who never
> smile.
> Even the drowned, the confined, the
> suspended
> Hold their unsmiling faces still
> forever.

There is no reason to suppose that Bosch did not believe as passionately and literally as Philip in the doctrine of eternal damnation. He may even have shared a then-popular opinion that not one soul had entered Paradise since the Great Schism of 1378. Whatever doubts he may have sheltered, whatever forbidden questions may have nibbled at him, whatever he may have felt about witchcraft hysteria and the Church's murderous repressions (and there are writers who view his depictions of torture as a covert attack on the Inquisition), there is no making a closet Satanist out of him, let alone an amiable modern agnostic. He meant what he painted—but is it possible that those nudes, black and white, sporting so wistfully together in the pool, that man playing with the bird perched on his foot, those riders in their somber frenzy, could have been created in utter condemnation by someone who did not mourn for them more than they mourn one another?

Detail from *The Haywain*,
right panel.

While Fra Angelico prayed and wept in his olive shade, there was different work doing in the dank fields of Flanders—wild seas to be banked out; endless canals to be dug . . . ploughing and harrowing of the frosty clay; careful breeding of stout horses and fat cattle; close setting of brick walls against cold winds and snow; much hardening of hands and gross stoutening of bodies in all this; gross jovialities of harvest homes and Christmas feasts, which were to be the reward of it.

John Ruskin, 1860

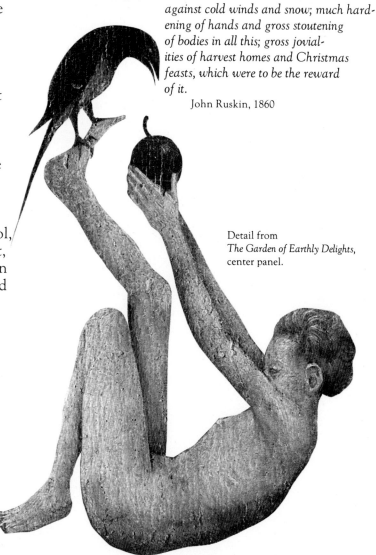

Detail from
The Garden of Earthly Delights,
center panel.

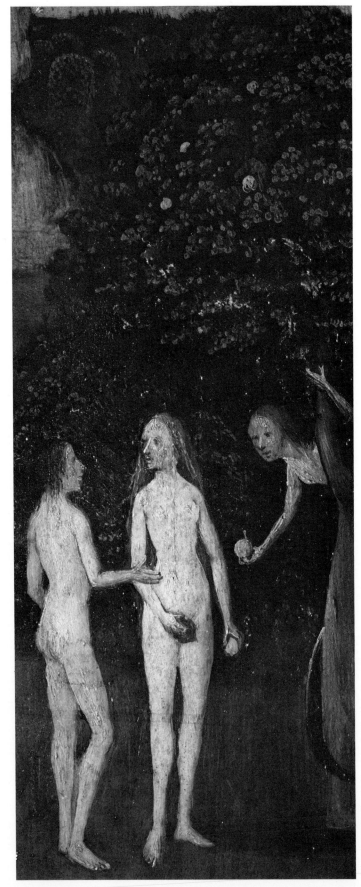

Bosch is always seen alone. He had a legion of imitators in his own time, but no school; and though he invented entirely new techniques of painting and drawing to meet the demands of his style, he left no direct descendants except Bruegel. He gives the impression of having been self-generated, like a whirlwind: beyond the training that he must have received from his father and uncles, there is no indication that he ever studied with anyone; nor do we have a single record of a friendship, a personal artistic contact, except possibly in the case of his lodge brother and workmate, the architect-engraver Alaert du Hameel. Critics tend to argue for the early influence of such Dutch painters as Dirk Bouts and Geertgen tot Sint Jans, as opposed to his great Flemish contemporaries—Jan van Eyck, Roger van der Weyden, Robert Campin, Hugo van der Goes. But for me, as for most lay viewers, Bosch comes burning out of nowhere, masterless, companionless, slashing like a demon's talon across the rich, placid fleshiness of Flemish art. How could a whirlwind have roots?

The fact is, of course, that in any art it is usually the grand originals who turn out to be the most profoundly connected to a particular time and place. There is a mysterious exchange that goes on

Detail from *The Haywain*, left panel.

in these matters, less to be documented than sensed,
a breathing shadow under the skin of the work.
What Shakespeare drew from Stratford, Isaac Babel
from Odessa, Flannery O'Connor from Milledge-
ville, Georgia, is balanced and affected by what
Stratford, Odessa and Milledgeville did to them.
King Lear says it: *"Nothing can be made out of
nothing."*

Rather than being, as I used to imagine him, a
modern sensibility trapped in muddy barbarism,
Bosch is what he is so intensely precisely *because* he

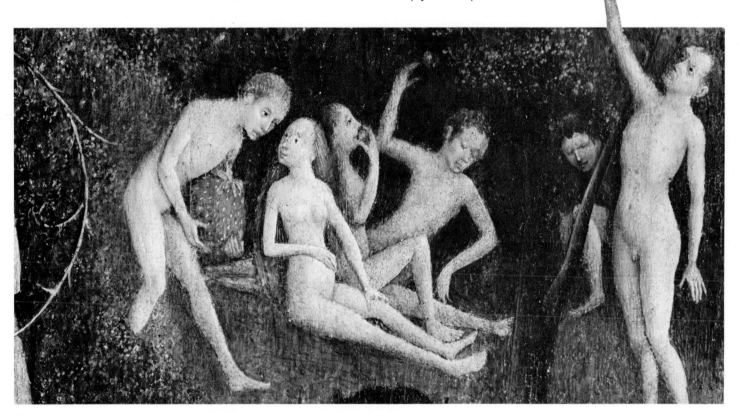

comes from Brabant, from the Netherlands, from
the late fifteenth century, and specifically from
's-Hertogenbosch. He may well have spent all his life
there (though Germano Mulazzani speculates that
he traveled and worked in Italy between 1499 and
1503), and it is inconceivable that his vision could
have fed entirely on a diet of minor civic duties,
piecework for the Brotherhood of Our Lady, and
the management of his wife's business affairs. What-
ever else they may be, Bosch's paintings are the
work of an explorer, a spiritual adventurer; and if
he never left 's-Hertogenbosch, the reason can only
be that he was nourished there as he needed to be
nourished. Everything necessary for his voyaging
must have been there for him.

Detail from
The Garden of Earthly Delights,
center panel.

The city was certainly no provincial backwater. Located in the wealthy heart of the House of Burgundy's dominions in the Netherlands, it was exposed to intellectual, artistic and doctrinal tradewinds that blew from Paris, Louvain, Brussels or Bruges. The area was also a center for followers of the new *devotio moderna,* which had actually originated in Holland, anticipating the Reformation in its emphasis on "sincerity and modesty, simplicity and industry, and, above all, constant ardor of religious emotion and thought" (Huizinga). Bosch's own Brotherhood of Our Lady was certainly affected by this movement, and his ferocious—and far from unshared—contempt for the noisome corruption of the orthodox clergy is always unmistakably clear. His true sympathies (as far as we can ever know them) appear to be with the ascetic and the hermit, with the huge peacefulness of his St. Christopher, and the helpless, irresolute longing of the Prodigal Son.

But Sandra Orienti, René de Solier, and many other critics, following the powerful lead of Wilhelm Fraenger (*The Millennium of Hieronymus Bosch,* 1952), feel that 's-Hertogenbosch's strongest influence on Bosch lies in the fact that it was a continuous ferment, both of more or less orthodox religious orders, and of occult studies and practices, of secret societies devoted to what might be called "underground learning." (It sounds remarkably like the Santa Cruz, California, area, where I live.) On the evidence of his art, they regard Bosch as an adept, profoundly steeped in every hermetic discipline of the time: from such comparatively accessible realms as astrology and the Tarot to the dangerously suspect lore of alchemy, Gnosticism, the Kabbala and other aspects of a reborn Jewish mysticism, as well as the interpretation of messages hidden in the various apocalyptic allegories. In the late Middle Ages, such researches were beginning to border on heresy; but in many quarters they were still considered an element of the search for God, to be pursued even at the peril of one's immortal soul.

Beyond this point lies the era's deadly preoccupation with witchcraft: the search for the Devil that truly evoked him on earth for three centuries. Whether or not Bosch believed in witchcraft, most of his 's-Hertogenbosch neighbors undoubtedly did, including the accused witches themselves, many of whom confessed voluntarily to their earnest Sabbats and Black Masses. He could have drawn the orgies depicted in *The Temptation of St. Anthony* as easily from popular fantasy as any personal observation— the images were part of his world's fabric, as the mysterious rituals and powers of the Mafia are of ours. If his art betrays any greater acquaintance with diabolism, Fray Sigüenza never saw it; and one can assume that he would have been looking.

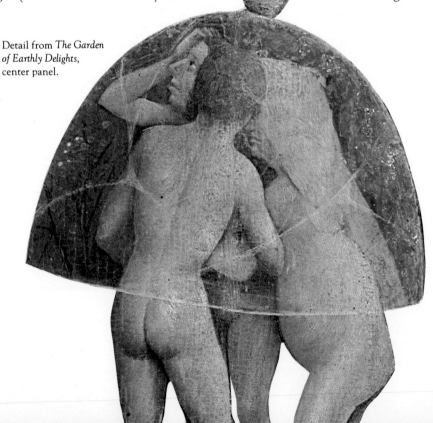

Detail from *The Garden of Earthly Delights,* center panel.

Detail from *The Temptation of St. Anthony,* center panel.

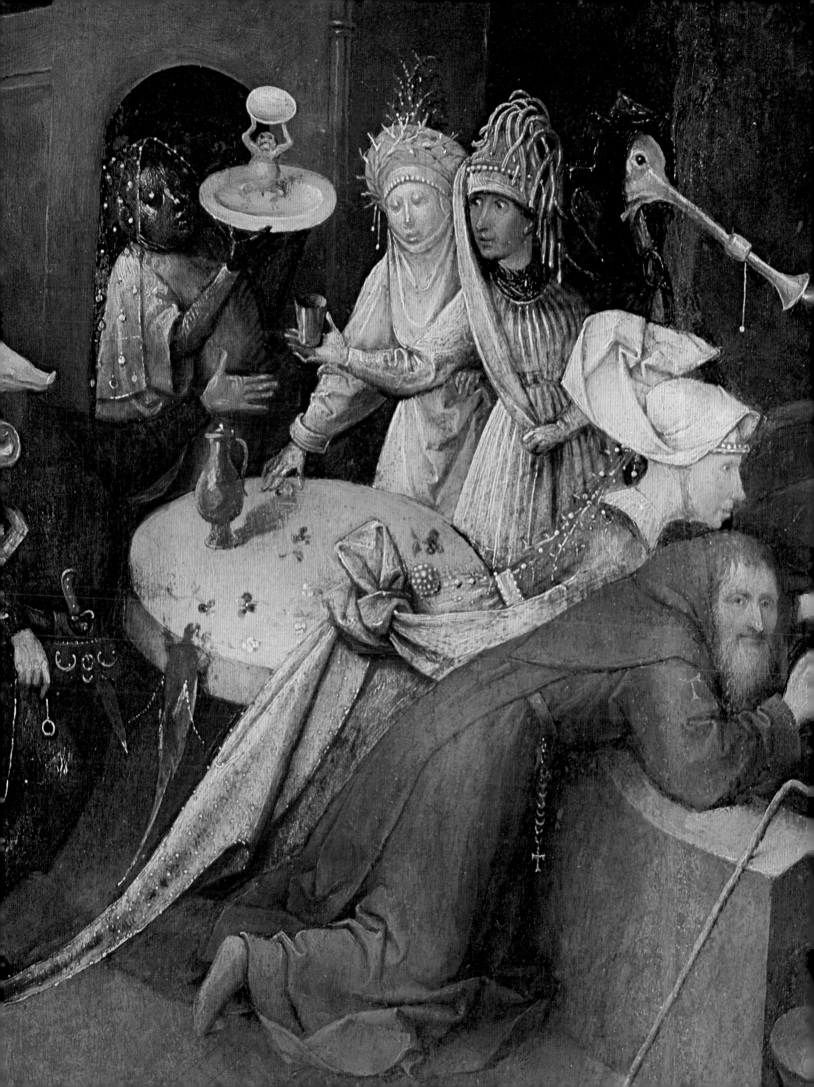

The same sort of Occam's Razor approach—using the sharp edge of direct reasoning to cut through a thicket of muddled thought—may be applied to the inevitable question of whether Bosch's "pleasing and fantastic" visions might have been drug-induced. In the 1960s I used to encounter (again, mostly at parties) an explication of Bosch based on his presumed familiarity with the makeup of the legendary ointment that witches supposedly rubbed on their bodies in order to fly, or to imagine that they flew. Silly drug-*chic* vulgarization that it was, the idea is not at all impossible in itself, or even unlikely. Natural hallucinogens—mushrooms, fungi, herbs, flower seeds—were as recognized and available in medieval Europe as their veiled presence in hundreds of folktales would suggest. But whatever Hieronymus Bosch may have been smoking, drinking or snorting, no other artist of his time can have been on it. It must have been private stock, like his dreams.

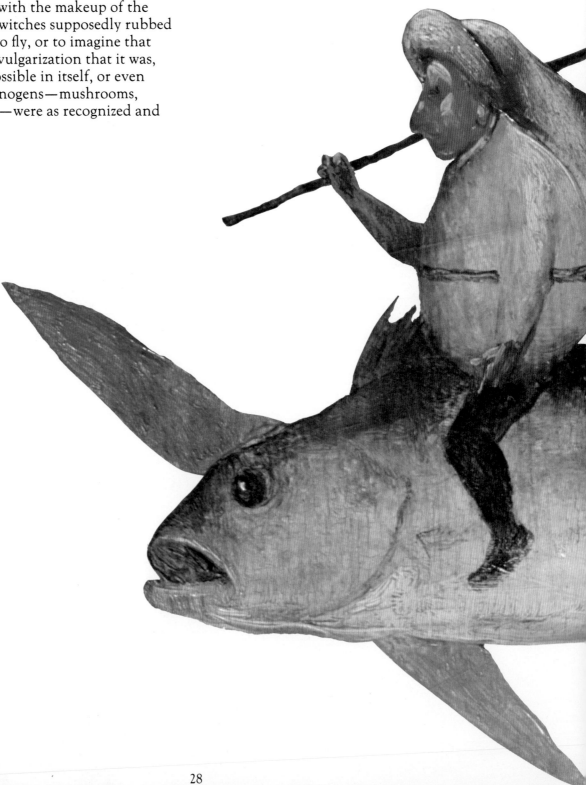

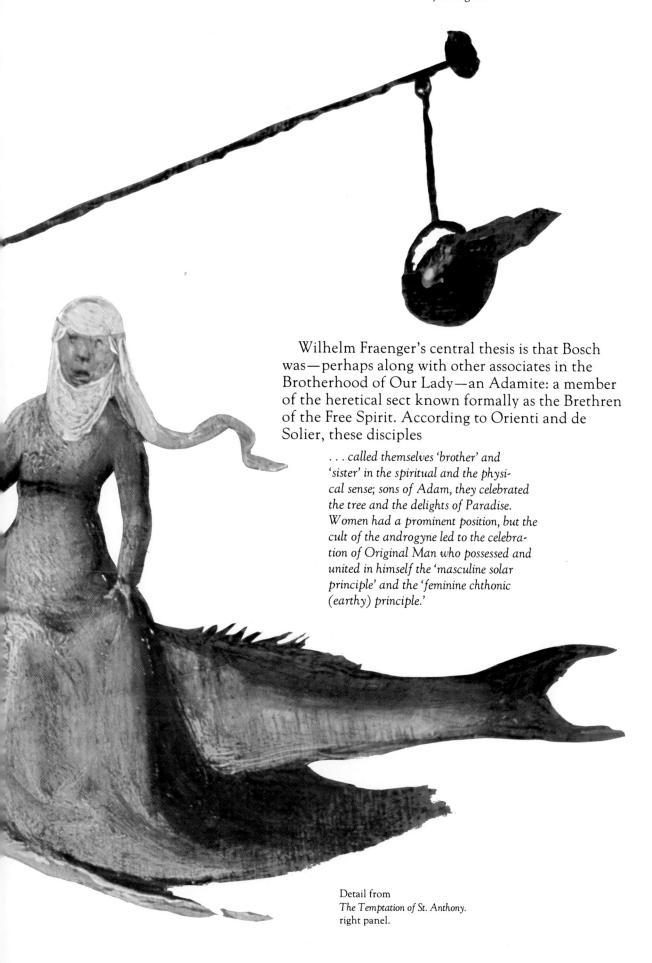

Wilhelm Fraenger's central thesis is that Bosch was—perhaps along with other associates in the Brotherhood of Our Lady—an Adamite: a member of the heretical sect known formally as the Brethren of the Free Spirit. According to Orienti and de Solier, these disciples

> *. . . called themselves 'brother' and 'sister' in the spiritual and the physical sense; sons of Adam, they celebrated the tree and the delights of Paradise. Women had a prominent position, but the cult of the androgyne led to the celebration of Original Man who possessed and united in himself the 'masculine solar principle' and the 'feminine chthonic (earthy) principle.'*

Detail from
The Temptation of St. Anthony.
right panel.

The Adamites believed in worshiping naked to-
gether, discarding both guilt and lasciviousness with
their clothes; and Fraenger claims that *The Garden of
Earthly Delights* illustrates the sect's "chain of ritu-
als," employing a symbolic language comprehensi-
ble only to the elect. Admitting that much of this
language is either lost or hopelessly ambiguous,
Fraenger nevertheless constructs an interpretation
of Bosch's paintings that leans heavily on images of
convoluted sexuality, of temptation leading to magi-
cal hallucinations, of alchemy, symbolic architec-
ture, and music, the whole underlain by the ritual of

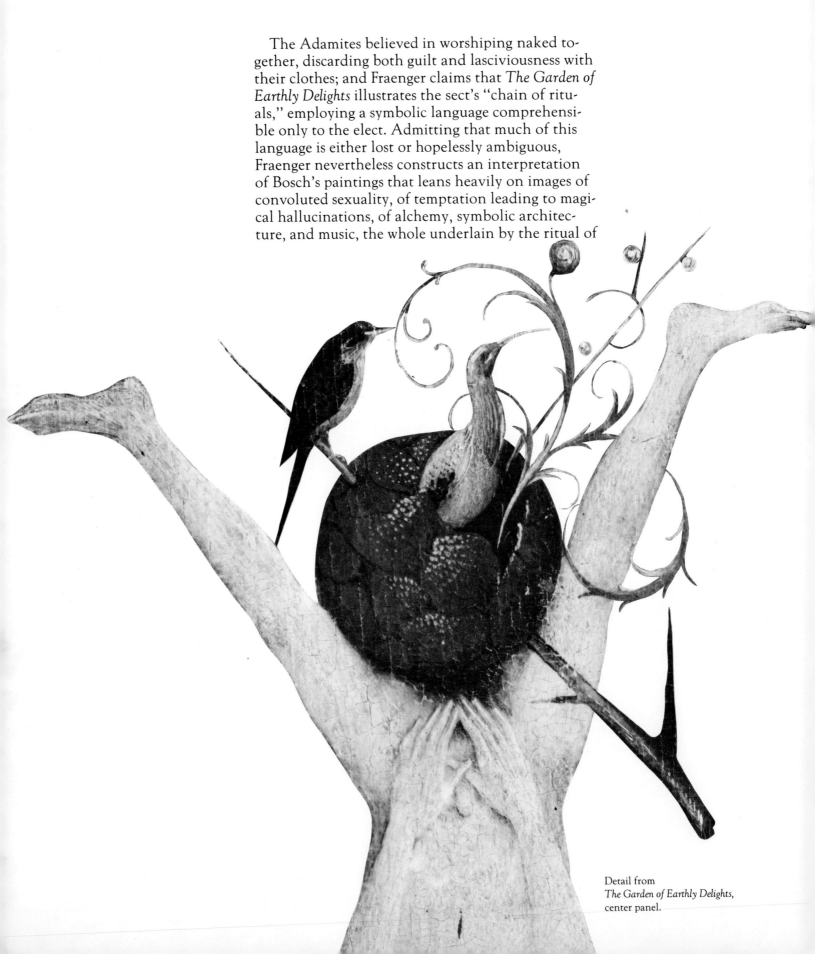

Detail from
The Garden of Earthly Delights,
center panel.

initiation itself, in which all veils are withdrawn and everything perceived by the senses takes on new meaning. Accurate or not, his study has been the strongest influence in the modern vision of Bosch—in a sense, it has already passed into folklore in its own right.

Erwin Panofsky, on the other hand, will have none of such theorizing, no matter how ingenious. In his *Early Netherlandish Painting*, he counters:

> There is no conclusive evidence for
> his familiarity with gnostic, Orphic,
> and Neoplatonic mysteries; and I am
> profoundly convinced that he, a highly
> regarded citizen of his little home
> town . . . could not have belonged to,
> and worked for, an esoteric club of
> heretics, believing in a Rasputin-like
> mixture of sex, mystical illumination
> and nudism, which was effectively
> dealt with in a trial in 1411 and of
> which no one knows whether it ever
> survived this trial.

To be moved by Bosch, to understand him in a place where all secret languages are the same, it is obviously unnecessary to know that the Conjuror in the painting of that name may be identified with the First Major Arcana of the Tarot, that a hollow tree symbolizes the alchemist's crucible, while a jug is frequently the sign of Satan; or to believe that the deeply enigmatic *The Marriage at Cana* actually refers to the wedding of Jacob de Almaengien, Master of the Brethren of the Free Spirit, who may or may not have commissioned Bosch's strangest and most intricate paintings. The scrutiny of Bosch's codes guarantees no final enlightenment—there are sim-

ply too many conflicts and obscurities, too many missing pieces, and no Rosetta Stone. What it can do at least is open up a wider range of speculation, and perhaps suggest the basic vocabulary of references that Bosch could have shared with the ordinary folk of 's-Hertogenbosch, as well as with any hypothetical elite. Faced with the work of a Warhol or a Lichtenstein, a fifteenth-century Brabanter might have been grateful to learn what a soup can was, or a *True Romances* comic book, and what peculiar resonances these objects had for the culture that produced them. Then again, of course, he might not.

> He sank his roots into the subsoil of
> popular and semipopular art—woodcuts,
> engravings, carvings in wood or stone,
> and, most important, book illumination.
> His archaism . . . bypassed the founders
> and drew inspiration from the sartorial
> eccentricities of the International Style;
> from the fantastic and often Rabelaisian
> humor of the drolleries in fourteenth
> and early fifteenth-century manuscripts,
> English as well as Continental. . . . And
> he must have been especially attracted
> by the illustration of such allegorical
> treatises and poems as the Pèlerinage
> de vie humaine *in which the literal pic-*
> turalization of verbal imagery had re-
> sulted in such . . . phantasmagorias as a
> big rock shedding tears from an enormous
> eye into a bucket, or severed human ears
> transfixed by a barbed skewer.
>
> Erwin Panofsky, Early
> Netherlandish Painting

The Garden of Earthly Delights is generally assumed to have been painted anywhere between 1485 and 1510. It is first mentioned by Antonio de Beatis, as quoted at the beginning of this essay: he evidently saw it in Brussels in 1517, a year after Bosch's death, in the palace of Henry III of Nassau, regent of the Netherlands. In 1568, after the duke of Alba crushed the first rebellion of the Low Countries' eighty-years' struggle for independence, and confiscated the possessions of Henry's heir, William of Orange, the triptych was taken to Spain. It was added to the royal collection in the Escorial in 1593, and Father Sigüenza describes it at length in his History of the Order of St. Jerome, published in 1604.

In trying to see this painting (or any other work of Hieronymus Bosch) through the eyes he meant it for, it is important to remember that, while he may not be the first major artist who was also a genuinely well-read man, the development of the printing

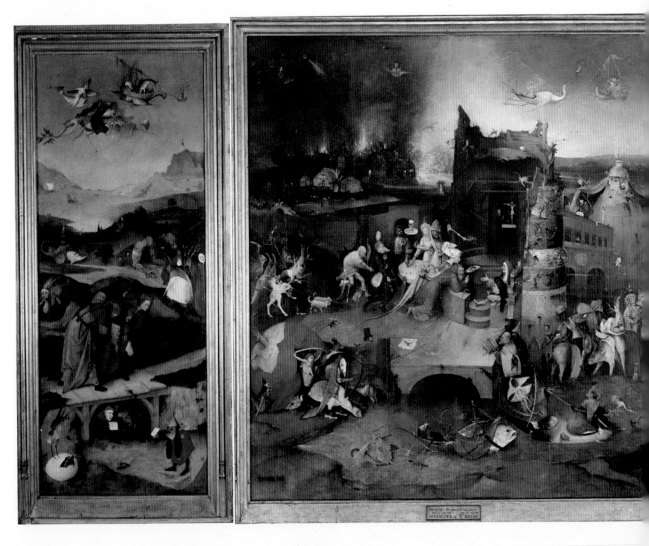

press in his lifetime makes him certainly one of the first to benefit from an increasingly literate and well-read popular audience. Many of the viewers of *The Temptation of St. Anthony,* for example, would have recognized details drawn from both the *Vaderboek* and *The Golden Legend*—two collections of the lives of the saints—and most would have been familiar with his other principal sources: the Bible (particularly the Book of Revelations), the Apocalypse, *The Vision of Tundale* (a horrifying tour of hell, actually published in Dutch translation in 's-Hertogenbosch in 1484), *The Book of Dreams,* Sebastian Brandt's *The Ship of Fools,* the *De Divinatione Daemonium* of St. Augustine, and the monstrous witch-hunter's manual, the *Malleus Maleficarum.* A smaller group might have studied the lives and works of such mystics as Jan van Ruysbroeck, Albertus Magnus and Denis de Rijckel; but many more would have devoted themselves to one depressing version or another of the

Ars Moriendi, the Fine Art of Dying. In this and similar literature were Bosch's dreams incubated.

But like Bruegel after him, Bosch draws constantly on folk material as well, making use of the most common proverbs, maxims and superstitions; dramatizing every kind of catch-phrase, whether at center stage or as background commentary, almost subliminal in its dailiness. Thus, for example, the operation in *The Cure of Folly* illustrates a saying of the time, "He needs to have his stone cut out," referring to a silly or simpleminded person. Here Bosch embroiders the satire with the wicked shorthand of a political cartoonist: the funnel on the false surgeon's head is a standard symbol of deceit and intemperance (it can hold nothing, and is often used by revellers as a noisemaker), while the dagger struck through the patient's purse indicates that the serene quack has marked it for his own. As for the dour, bored-looking nun, the closed book balanced

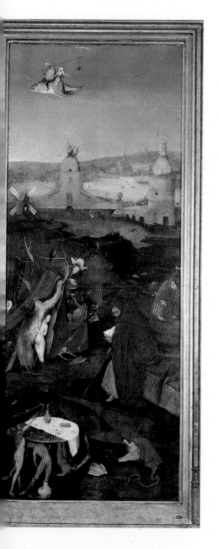

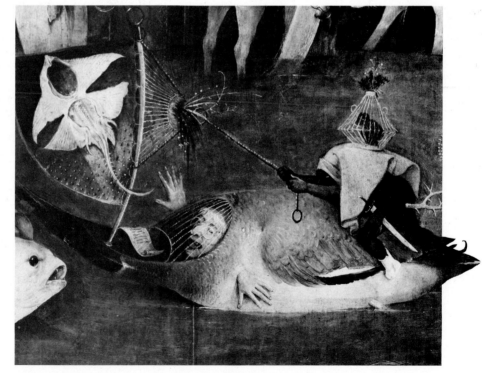

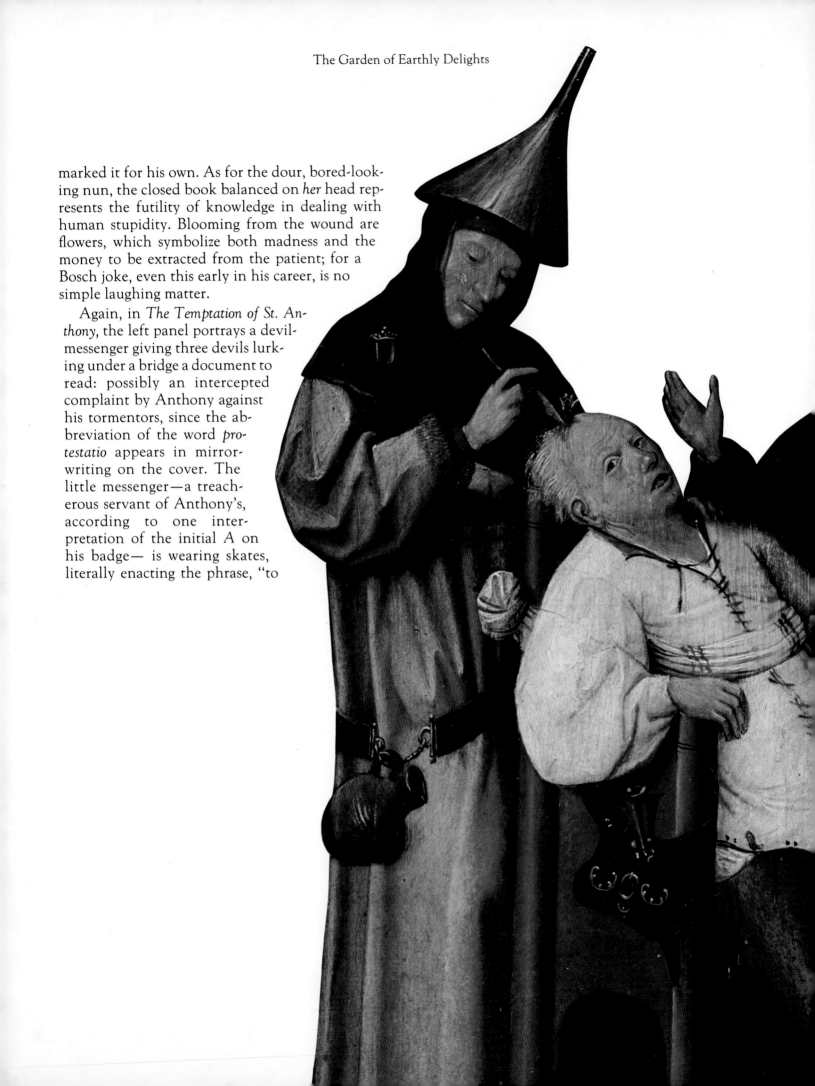

marked it for his own. As for the dour, bored-looking nun, the closed book balanced on *her* head represents the futility of knowledge in dealing with human stupidity. Blooming from the wound are flowers, which symbolize both madness and the money to be extracted from the patient; for a Bosch joke, even this early in his career, is no simple laughing matter.

Again, in *The Temptation of St. Anthony,* the left panel portrays a devil-messenger giving three devils lurking under a bridge a document to read: possibly an intercepted complaint by Anthony against his tormentors, since the abbreviation of the word *protestatio* appears in mirror-writing on the cover. The little messenger—a treacherous servant of Anthony's, according to one interpretation of the initial A on his badge— is wearing skates, literally enacting the phrase, "to

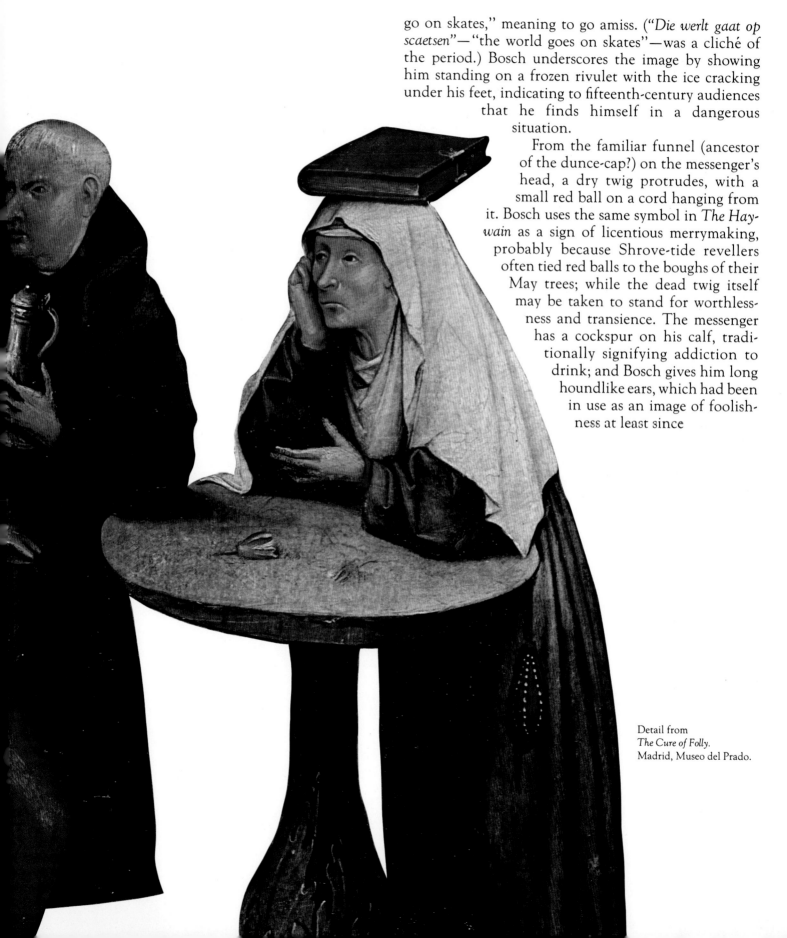

go on skates," meaning to go amiss. ("*Die werlt gaat op scaetsen*"—"the world goes on skates"—was a cliché of the period.) Bosch underscores the image by showing him standing on a frozen rivulet with the ice cracking under his feet, indicating to fifteenth-century audiences that he finds himself in a dangerous situation.

From the familiar funnel (ancestor of the dunce-cap?) on the messenger's head, a dry twig protrudes, with a small red ball on a cord hanging from it. Bosch uses the same symbol in *The Haywain* as a sign of licentious merrymaking, probably because Shrove-tide revellers often tied red balls to the boughs of their May trees; while the dead twig itself may be taken to stand for worthlessness and transience. The messenger has a cockspur on his calf, traditionally signifying addiction to drink; and Bosch gives him long houndlike ears, which had been in use as an image of foolishness at least since

Detail from
The Cure of Folly.
Madrid, Museo del Prado.

the beginning of the fourteenth century. (The portrayal may trace back much further, to ancient depictions of a monster-people called the Panothii, about whom Vicentius Bellovacensis wrote that they lived in the region of Scythia and had ears so huge that they used them as blankets.) It's all hardly different from the accepted Saturday-matinee code of my childhood, when villains still had mustaches and cast bigger shadows than other people, and Bad Girls smoked cigarettes very differently from Good Girls.

Incidentally, the messenger's predatory beak may derive directly from a theatrical mask. Devils were commonly presented onstage as having birds' heads (there is even a piece in which a devil in fear of punishment says to a companion, "Lucifer will cut off our beaks for this"), and Bosch may very well have designed such costumes for the mystery plays put on by the Brotherhood of Our Lady.

It is worth studying this same small corner of a vast and overwhelming vision a little more closely, in our attempt to understand how Bosch's next-door neighbors might have seen it. Of the trio under the bridge, the one who is reading is a cleric or scholar: the blue cap or hood he wears indicates his hypocrisy, since blue is the color which in many folk expressions stands for deceitfulness. In another play of the time, *The Tree of the Scriptures*, the virgin Elck Bijsonder (literally, Everyone Individually) is urged by a satanic being to act sanctimoniously: "Cover your head with blue devotion."

The dancing bear—notice the ring in its snout—next to the cleric-devil was a popular symbol of diabolical wrath in the Middle Ages. One medieval author writes that there are bears in hell; another compares its death-grip to that of the Devil on his prey. The bear could also personify lust, and Bosch probably employs it in that capacity in *The Garden of Earthly Delights*.

The third member of the party is a water-rat with the wings of a jay. Like most of Bosch's hybrids, he is not randomly invented, but is rather a careful blend of traditional attributes. The rat is almost always a sexual figure in Netherlandish iconogra-

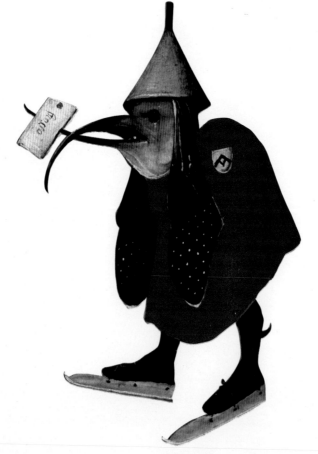

Details from
The Temptation of St. Anthony,
left panel.

phy: *to catch a rat* was fifteenth-century slang for pregnancy, and the word *ratteken* (little rat) was another term for the vagina. Bosch arms him with a long knife as an emblem of pugnacity (more specifically, in Bosch's art, of drunken rage), and adds the jay-wings to signify stupidity. This usage has also survived, at least in Flanders; and in Ghent a drink is called a *gaai* (jay), perhaps on account of the bird's raucous shriek.

To complete this perfectly ordinary example of Bosch's texture, we may briefly consider the pied crow who lies dead on the ice, struck by an arrow. The rat-devil is probably the killer—there is another arrow thrust through his girdle—but the piquant aspect is the possible association of the scene with the saying, "He has shot a crow," which is known to have referred to someone involved in smuggling or other illicit trading practices. The connection with that particular catch-phrase is unprovable; what should be clear by now is that the critics who hunt for double and triple undercoats of significance in Bosch's paintings are entirely right to do so. Over five hundred years meanings silt up like river mouths, rise and wear away like mountain ranges, change their shapes like coasts, or vanish altogether under layer upon layer of historical debris, like empires. The secret messages and allusions are always there—the point is, simply, that they were not always hidden. In Hieronymus Bosch's world, everything stood for something truer than itself. In the words of Huizinga:

To which T.H. White adds, in my battered, beloved teddy-bear copy of his *The Bestiary*:

Every possible article in the world, and its name also, concealed a hidden message for the eye of faith. It was hardly possible to play chess without reading a 'Jeu d'échecs moralisé', in which the names of the various gambits would teach a man that 'he who gives not what he esteems, shall not take what he desires' or that 'he sees his play at hand who sees it at a distance'. . . . The meaning of symbolism was so important to the medieval mind that St. Augustine stated in so many words that it did not matter whether certain animals existed: what did matter was what they meant.

The Middle Ages never forgot that all things would be absurd, if their meaning were exhausted in their function and their place in the phemomenal world, if by their essence they did not reach into a world beyond this. . . . Nothing is too humble to represent and to glorify the sublime. The walnut signifies Christ; the sweet kernel is His divine nature, the green and pulpy outer peel is His humanity, the wooden shell between is the cross. . . . The world, objectionable in itself, became acceptable by its symbolic purport.

In *The Garden of Earthly Delights,* many of the standard representations can be identified: the riders who ring the pool in the central panel are all mounted on animals symbolizing lustful vitality, while the bathers luxuriate under the eyes of the peacock of vanity, the crows of unbelief, the owl of forbidden wisdom. But most of the folk imagery begins to turn inside out, like an optical illusion, as one studies it; to double back on itself, bending into a wondrous theological Möbius strip. Consider the scene that appears on the outside of the triptych when the two side panels are closed: the Third Day of Creation, with light and dark separating in the firmament, and the Earth heaving itself up between, slowly taking shape in the gray mist. Plants and trees are appearing as the water recedes, and there is even a bit of a rainbow. Done in grisaille, which is un-usual in Bosch's art, it is a vision of great and wearisome effort—the very transparency of the globe makes it seem as though God were struggling to hold it all together in his imagination—but

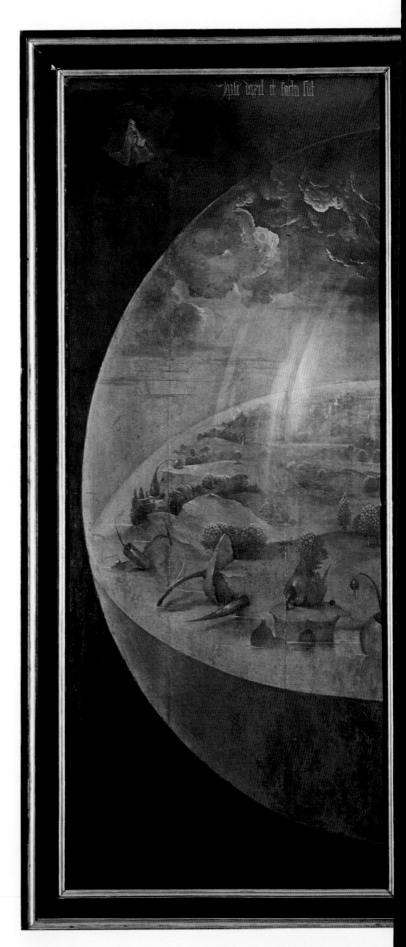

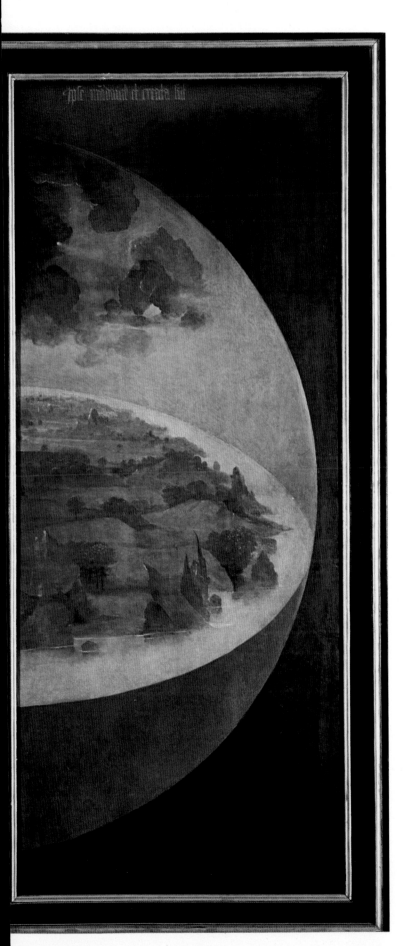

chillingly, uniquely beautiful. I thought of this painting when I saw the first photographs of the Earth from space.

But along the emerging shores, like the first scouts of an invading army, are encamped a strange array of spiky, overblown plants, vaguely but insistently menacing. They don't belong here, or anywhere: like the winged rat, like so many of Bosch's most brilliant inventions, in paradise, on earth and in hell, they are hybrids, constantly transgressing the border between beast and human, vegetable and mineral, life and death. Whatever Bosch intended these particular half-creatures to represent, they are alarming intruders by the mere fact of their existence. The hybrid was outside the bestiary, free of moralizing, of having to embody anything but the wickedness of its unnatural begetting. And here they are, waiting for the Garden and mankind to be born, and God seems very small and far away, already retreating from the consequences of his world.

The Third Day of Creation,
the closed wings of *The Garden
of Earthly Delights* triptych.

The Garden of Earthly Delights,
left panel. Madrid, Museo del Prado.

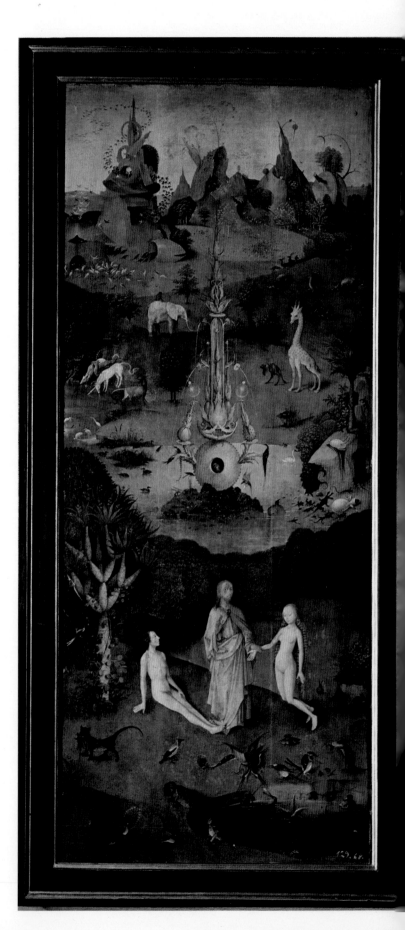

From this profoundly uneasy beginning, the left-hand panel of the triptych goes on to depict the Sixth Day, in such an Eden as no artist but Bosch ever conceived. The Hell panel and the Earthly Delights panel itself are perhaps more celebrated, but in certain ways this section remains the most uncannily compelling element of the painting.

Timothy Foote describes the scene as one of "pastoral serenity," but the illusion of blessed peacefulness in that Garden endures only for as long as do our conditioned expectations of Eden. There are the new-made Adam and Eve in the foreground, naked and awe-struck, with Jesus present in the ancient tradition of showing their creation as accomplished by the Word of God. The trees around them are heavy with appetizing fruit; there is the Fountain of Life beyond the trees, and there is the first elephant, the first giraffe—even the first unicorn, drinking from the waters of the Fountain! It is all more charming than anything else in Bosch, if you keep your distance.

But the little pool by which Adam and Eve have awakened is dark and stagnant, and seething with sinister life. From the more-or-less normal cat carrying off its kill, to the miniature dinosaur, the two cockatrices fighting over a dead frog, the three-headed crane striking at everything in sight, almost every one of these dawn beasts—even Isidore of Seville's legendary Dragon Tree, like an overgrown turnip behind Adam—is charged with a murderous energy hardly to be matched in hell. Jesus holds Eve by the wrist, apparently wedding her to Adam, and doesn't seem to notice anything else going on.

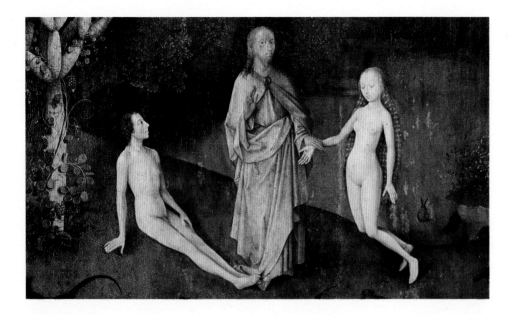

Most critics, including Fraenger, still interpret this scene much as Father Sigüenza must have done. The Fall is implicit in Eve: sin and death enter the world through her, and Bosch is well within church doctrine in prefiguring the flourishing of iniquity from the instant of her creation. What Jesus is seeing, as he stares away into time, is the whole inevitable panorama of human depravity and damnation that has been set in motion at this moment.

But I've never altogether believed that. I can imagine Bosch being just as happy to have it believed, since the suggestion that the Garden of Eden was somehow tainted with sin before mankind ever existed must surely be a heresy important enough to have a name, and possibly a crusade, of its own. It doesn't seem to have been an Adamite tenet; it might fit with the Gnostic insistence that all matter, not merely weak human flesh, is inherently evil. In any event, it makes for a Garden in which, finally, the only innocence is that of the doomed pair themselves, wide-eyed Adam and scapegrace-madonna Eve. Humanist sentimentality again, most likely.

The equivocal treatment of this ominous paradise continues into the background, to a curiously crab-like Fountain of Life and the contorted rock formations beyond. (*There,* by the way, was one landscape that turned up on a regular basis in pulp science-fiction illustrations.) Most of the browsing and swimming beasts of Eden are comfortingly ordinary, and always graceful (Bosch must be the only artist who ever made a cow look dainty!); but that three-headed salamander (not only immune to fire, ac-

cording to the bestiaries, but also the most venomous of living creatures) and that giant termite-thing crawling out of the Fountain toward a cave have a dank purposefulness about them, as though they were hungry to hide in darkness and evolve into something hungrier. Twined around a palm tree above the cave, the serpent looks on unobtrusively.

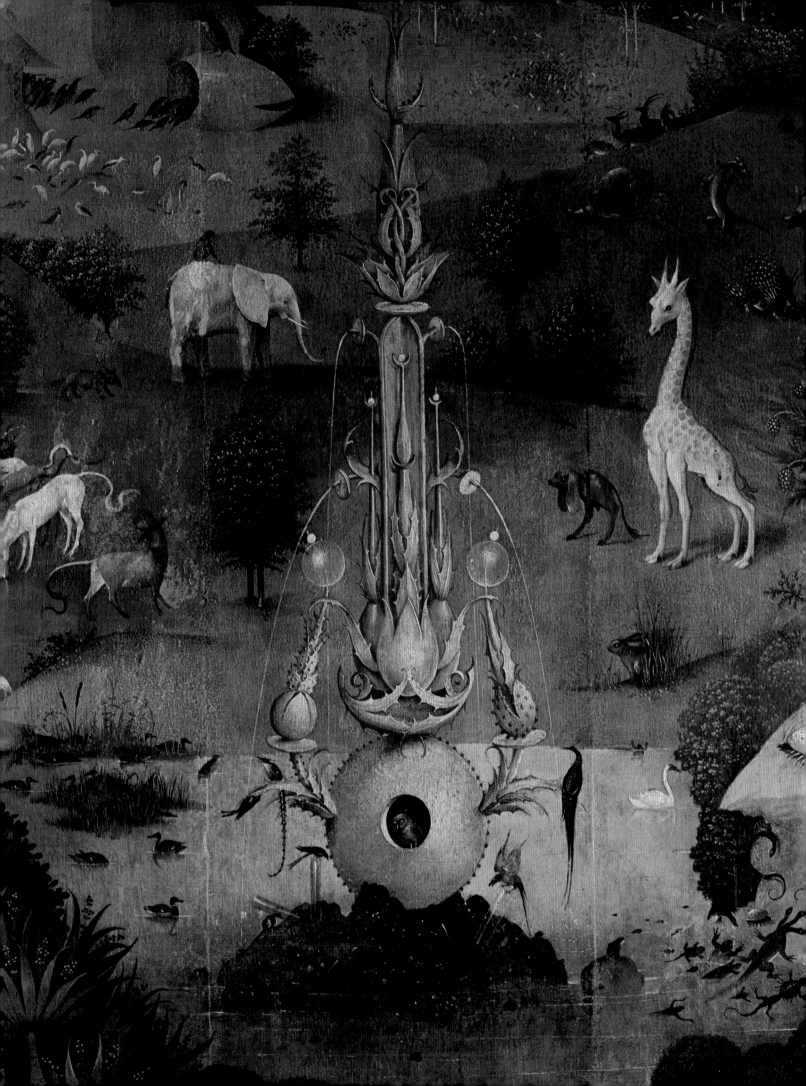

Further on a lion has killed a gazelle, and a wild boar lunges after some sort of dancing crocodile that capers out of range on its hind legs. Flocks of birds are swarming like insects out of the gilded rocks, while a stream of Bosch's ever-portentous crows are marching into a stone egg just below. The Fountain itself is prominently decorated with the crescent moon—almost invariably a mark of the Devil, with its obvious associations with Islam and the Turk. Bosch crowns a demon-bishop's staff with it in *The Temptation of St. Anthony*, and sets it on the battlements of hell in *The Haywain*.

From within the Fountain's circular base there peers an owl, perhaps the most disquieting creature of all to introduce into any fifteenth-century Garden of Eden. The serpent at least belongs there; but the owl, bird of magicians and philosophers, sacred to Athena, symbolized the search for hidden understanding long before Christianity branded that search Original Sin. The owl's unblinking gaze implied the discipline and concentration of the alchemist, rather than the ascetic; and the medieval church regarded contemplation somewhat as we do nuclear fission—not necessarily evil in its nature, doubtless beneficent under controlled conditions, but appallingly dangerous in any hands except those of a saint. Not to mention the entirely unpredictable side effects.

According to White's *The Bestiary*, which is actually a translation of a Latin prose manuscript copied in the twelfth century, there is another equally interesting significance to the owl:

Owls are symbolical of the Jews, who repulse Our Saviour when he comes to redeem them, saying: 'We have no King but Caesar.' They value darkness more than light.

Most critics believe Bosch to have been remarkably familiar with legends and customs concerning the Jews, however much they may quarrel about their importance in his work. Wilhelm Fraenger attributes this knowledge—and a great deal else—to the relationship between Bosch and the shadowy Jacob de Almaengien, a converted Jew who was a member of the Brotherhood of Our Lady. Fraenger claims that de Almaengien was in fact the Grand Master of the Adamites and Bosch's personal magus, his guide to the heretical sciences and the fulcrum of his symbolism, as that owl becomes the focus of the whole Eden panel after a while. Panofsky says that it's all nonsense—there's no proof at all that he was anything of the kind.

Details from
The Garden of Earthly Delights,
left panel.

43

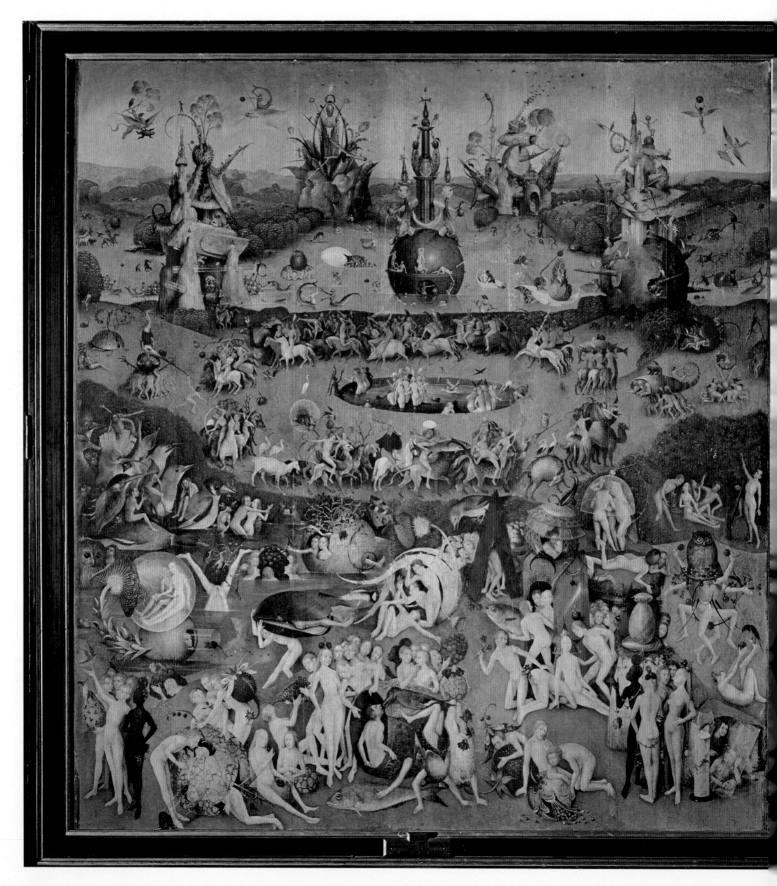

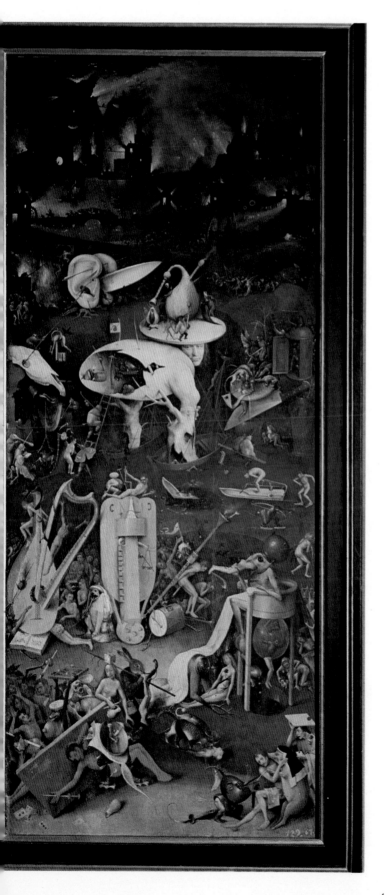

This seems as good a point as any, as we turn from one Garden to another, to enter my own mild heresy: not only do I believe that the left and center panels are meant to be the same Garden, but I suspect as strongly that this terrestrial garden spot in turn becomes hell on earth in the final, right-hand scene. For locating all three panels on the same earthly site, I can only offer as physical evidence the similarities of the three landscapes: each is interlaced with bodies of water, and shares a common horizon line punctuated by vertical structures. Bosch, for whom even a dry twig had its particular reason, could never have created such a composition by accident. The flow and feel of the land itself is consistent, from Eden's green eagerness to hell's frozen chaos; all that has really changed is the neighborhood. Mad visionary, placid taxpaying craftsman, tempted Puritan *voyeur* or Christian hedonist, Bosch was a pessimist before he was anything else, and pessimism has only one orthodoxy, transcending all sects and times. It is that the human fate is always to dream of heaven and create hell, over and over, under many names, including heaven.

The Garden of Earthly Delights,
center and right panels.
Madrid, Museo del Prado.

If the Eden panel represents humanity's sinister spring, the Garden of Earthly Delights itself is high summer incarnate. Everything is moist, soft, rotten-ripe, falling or bursting thickly open of its own warm weight. The landscape is insane with fecundity, rather like a New Yorker's dream of California: even the Martian rock formations of Eden have gone to seed, melting into pulpy vegetable castles, mongrels of cactus, pineapple, gourd, puffball, with spiny succulent leaves for turrets and plumed weeds for banners, and walls like chunks of honeydew or slices of veiny pink beefsteak tomatoes. They are fermentation made flesh; their impossible vigor embodies the sweet, mazing anarchy of this Garden where there are no rules, no boundaries, where everything can couple fruitfully with everything else—flower with stone, animal with human, human with water. If we cannot look at the scene with the fifteenth century's fascinated horror of the hybrid, we can still smell that eternal summer moment, and perhaps breathe the bewitchingly desolate air of perfect freedom.

The Garden's inhabitants have grown smaller since Eden, in proportion to their surroundings. Adam and Eve appear much larger than the swift miniature monsters of the foreground pool, and on a generally normal human scale with the creatures around the Fountain of Life. But their sinful descendants are constantly dwarfed by the birds that act as aloof companions, by the giant mussel and crustacean shells in which they hide away to make love in guiltless *ménages,* and by the huge strawberries, cherries, grapes, blackberries, pomegranates and seed-pods that serve them as well for bedrooms as for sport or nourishment. In hell they will be more shrunken still, compared with the demonic machines that torture them. Bosch's sense of scale is one of his strongest and most subtly employed gifts: here he handles it as though to suggest that the distant God of the Third Day is moving even further and further away from humanity, losing sight only of us.

In considering the basic folk-symbols involved in this panel, it's interesting to note that Fray Sigüenza's *History* refers to the entire triptych as *The Strawberry Plant,* stating that it centers around:

> . . . a picture of the transient glory and the fleeting taste of the strawberry, and its pleasant fragrance that is hardly remembered once it has passed.

Detail from *The Garden of Earthly Delights,* center panel.

Detail from *The Garden of Earthly Delights,* left panel.

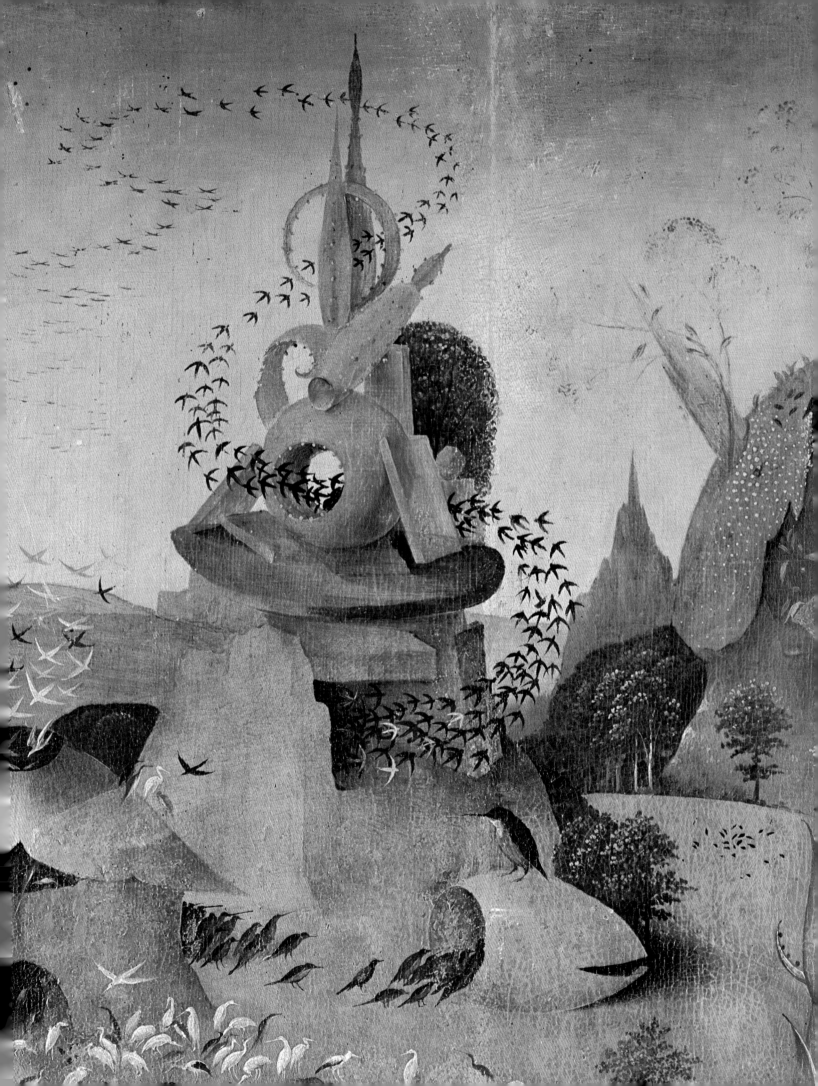

For Bosch and his audience, any round, ripe
fruit—or, for that matter, the eggs that so
many figures in his work balance on their
heads, carry in their hands, or crawl busily in and
out of, like children playing house—usually stands
for sex and reproduction, as does anything to do with
water. Lovers are the children of Aphrodite, who was
born of the sea. (Indeed, long before the Age of Aquarius
discovered hot tubs, the Netherlandish expression for
lovemaking was "swimming in the bath of Venus.")
Fish serve as ribald phallic symbols; clams, mussels
and oysters suggest the slippery, pungent se-
crecy of the bridal chamber; the pools and
swamps common to Bosch's landscapes repre-
sent the fluid matrix for conception, and the
immense birds that crowd them are often those
associated with lust and fertility, such as the king-
fisher or the mallard. On this level the Garden's
humid pleasures would have been perfectly accessible
to any ordinary citizen of 's-Hertogenbosch, with-
out benefit either of secret religious affiliations or
psychoanalysis.

On the other hand, a viewer moderately versed in
alchemy (in which the procreative force was at the
heart of every kind of transformation) could
have translated all this shorthand just as com-
fortably. Setting Fraenger's Adamites aside for
the moment, it is probably true that, after pop-
ular Christian folklore, the imagery of alchemy
is the most powerful influence on Bosch's sym-
bolism. It would be surprising to learn other-
wise, since two of his wife's brothers were
chemists, and in the fifteenth century, Euro-
pean chemistry had not yet become altogether
distinct from practical alchemy. There is no
more need to prove that Bosch was an adept than
there is reason to doubt that he did speak the
peculiar, intentionally elusive language of that
most peculiar art. For someone who may never
have left his home town, Bosch spoke a lot of
languages.

Many years ago, a wandering friend of mine,
known in some realms as Schmendrick the Magi-
cian, unwittingly enunciated the fundamental
principle of alchemy while he was talking about
something else. We tend to make most of our
discoveries that way, Schmendrick and I.

*For only to a magician is the world forever fluid, infinitely
mutable and eternally new. Only he knows the secret of change,
only he knows truly that all things are crouched in eagerness to
become something else, and it is from this universal tension that
he draws his power.* The Last Unicorn

Aristotle, the philosophical father of alchemy, as of all Western scientific speculation for two thousand years, felt much the same way. His premise of a prime matter forming the basis of all terrestrial substance, and therefore—in theory—capable of limitless change, kept generations of honest metalworkers and dyers, astrologers, learned Arab mathematicians and all manner of obsessed amateurs struggling to "perfect" base metal into gold, exactly as the human soul was thought to yearn toward perfection in heaven. The artisan-alchemist figuratively "killed" lead, copper, or iron by converting it to a black oxide, and then "revived" it by combining it with mercury or arsenic to create a whitish alloy. Further chemical deaths and resurrections were meant to produce a specific series of colors, culminating in triumph with pure gold. The concept was admirably suited to the medieval need for universal symmetry. It did help things along (as generations of charlatans had learned) if you had a bit of gold to start with.

But by Hieronymus Bosch's time, alchemy—which had already vanished once after the fall of Rome, to be rediscovered in Arabic translations by such twelfth and thirteenth-century scholars as Roger Bacon and Albertus Magnus—was on its way out again. (Isaac Newton still believed in it, however, as late as 1700.) The practical alchemists had largely given up on transmutation and were hard at work founding modern chemistry and pharmacology. They left the field to the mystics among them, who had always been far less concerned with experiments, reagents, distillation, and laboratory apparatus, than they were in the symbolism of these things, and in the Great Metaphor of human perfection into which they could all be made to fit. Their one technical interest was in the quest for the Philosopher's Stone, the elixir of life—a pursuit they shared with earlier Chinese and Arab alchemists. The rest was allegory, numerology, interpretations of commentaries upon cryptic commentaries, and the general business of divine revelation.

The inherently secretive nature of alchemy makes it impossible for us ever to be certain of the degree of Bosch's involvement with the art. Almost from the beginning, those first metallurgists, anxious to guard their trade secrets, invented arcane code names for every piece of equipment, every technique employed, every reaction produced. A mineral might be referred to only by the astrological sign of the heavenly body believed to control it; a specific reagent might be spoken of in the trade as "dragon's tongue" or "bile of toad." By 1500 all that counted was the game of hidden knowledge: the secret for its own sake. The word *occult,* in its modern sense of forbidden magic and sinister but alluring powers, came into use at that time.

To an initiate, then, *The Garden of Earthly Delights* would have seemed an inexhaustible playground of alchemical allusions. The geometrical center of the Garden panel—as the owl in the Fountain was the hub of Eden—is the egg balanced on the head of one of the riders. In alchemy the egg corresponded to the transforming alembic, or means of distillation; while each color signified a different stage of the *opus.* (For example, the black crows of the Eden panel would have been seen as representing the *nigredo,* the first killing of the metal.) Almost every object has some sort of mystic meaning: the glass tubes and phials, the transparent air-bubbles, the Fountain itself, the key, the pendulum, the ladder—let alone the Tree-Man of hell, whom we will speak of again; and that odd little inverted Y-shape, which, for at least one critic, indicates a connection with Pythagorean philosophy. The man standing just behind the wimpled pig in a corner of the hell panel is either carrying tablets inscribed with alchemical texts, or simply a damning set of tax rolls. It depends on whom you read.

There is literally no end to it, if you're involved in translating Bosch on this paper-chase basis. My favorite debate concerns the two gigantic knives shown mincing up the condemned in hell. Both of them bear what appears to be the letter M on their blades, which was at first thought to be the hallmark of some collaborator, or possibly that of a local cutler disliked by Bosch. But it has more recently been taken as alluding to the *Liber Mundi* of the Rosicrucians; as *Mundus*—universality—by the influential Charles de Tolnay; and by Jacques Combe as signifiying both sulphur, in alchemical terms, and Scorpio in astrology. Walter S. Gibson, much more cautious and skeptical, nevertheless reminds us of the medieval prophecies that the name of the Antichrist would begin with this initial. There's no end to the game.

Perhaps Fray Sigüenza was right to see it mainly as a simple, persuasive Christian allegory. In Bosch's hell the juicy, flowering fruits have rotted away; the rich eggs have become empty, brittle shells; the sensuously warm waters of the Fountain have turned to ice. In the end, all are symbols of sterility, transience, and death.

In the Garden's graceful daisy-chain swirl of erotic activity, Bosch heightens both the sense of feverish sensual greed and of that strange, contradictory delicacy by treating each individual figure like a miniature, in the manner of an earlier time. Two contemplative groups at the furthest corners of the foreground stand out strikingly. The six people at the lower left have their backs to the Garden, and one man is gesturing toward Adam and Eve in the Eden panel, as though to recall to his companions their divine origin. The black nude

appears thoughtful, the others no more than mildly curious.

In the right-hand corner we find perhaps the most provocative and baffling image in the whole enigmatically wicked picnic. Two men and a woman are emerging unseen from a hole in the ground: the first man might be wearing a hair shirt or an animal skin, making him the lone clothed figure of the triptych, except for Jesus. The man behind him is only a face; but the woman, her mouth sealed (another hermetic motif, to some), a large glass cylinder somewhat distorting her features, looks hauntingly doleful as she leans on one elbow and gazes off at nothing in particular. Dirk Bax, an authority on medieval Dutch literature, takes the trio to represent Adam, Eve, and Noah, referring to the theme (apparently treated by Bosch in two lost paintings) of lustful humanity sporting unknowingly on the brink of the

Detail from
The Garden of Earthly Delights,
center panel.

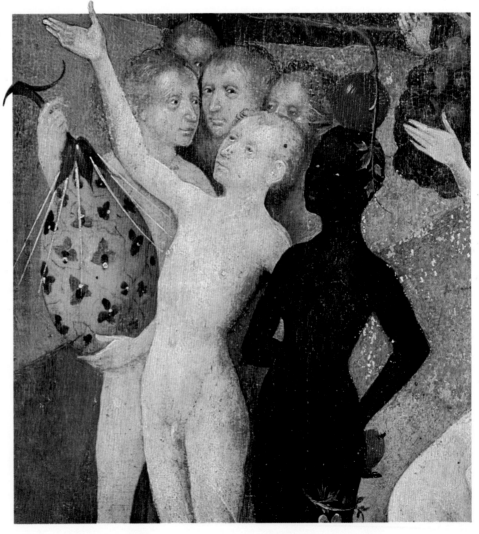

Flood. The subject was common enough in a time that saw the shadow of the Antichrist in every occurrence—a sick cow, a bad harvest, a madwoman's rumored babble of demon-beasts, a new Turkish triumph—and which generally expected Armageddon and the world's end in the demi-millennial year of 1500. Eve's mute air of hopelessness might have been no more a mystery than the prophetic sorrow of the Madonna to such an audience.

Wilhelm Fraenger, for his part, agrees that the woman is indeed meant to be Eve, but holds that she is actually accompanied by Bosch himself and Jacob van Almaengien, who he believes commissioned the painting. And we might just as well mention here Fraenger's hypothesis that the triptych is to be read from right to left, beginning with the hell which awaits the orthodox, and moving on to the heretically innocent joys advocated by the Brethren of the Free Spirit. For Fraenger the ambiguous Eden panel is the true climax of the allegory: the Paradise of Adam and Eve renewed, literally recreated through the labors of the blessed. It's an attractively adventurous idea, and at very least consistent with Fraenger's basic theory; but it does tend to reduce Bosch to the role of a journeyman illustrator, practically painting by numbers, and his dainty voluptuaries to a sort of dutiful construction gang. Even if it did reveal the entire mystical structure of *The Garden of Earthly Delights*, beyond any denial, Bosch himself would get away once again. He always does.

Which is, of course, the enduring fascination of that Garden: the evasive, teasing sense that it contains in itself every explanation, every system of belief—established or outlawed—available in late-medieval Europe; but that somehow none of them contains the Garden.

Detail from
The Garden of Earthly Delights,
center panel.

. . . looking at Michelangelo's paintings, it is hard not to feel that he looked on the Last Judgment mainly as an occasion for painting a splendid picture, while Bosch's visions seem to reek of hell itself.

Timothy Foote, *The World of Bruegel*

. . . it is good that, if the love of God does not restrain you from sin, the fear of hell at least should restrain you.

Thomas à Kempis, *Imitation of Christ*

51

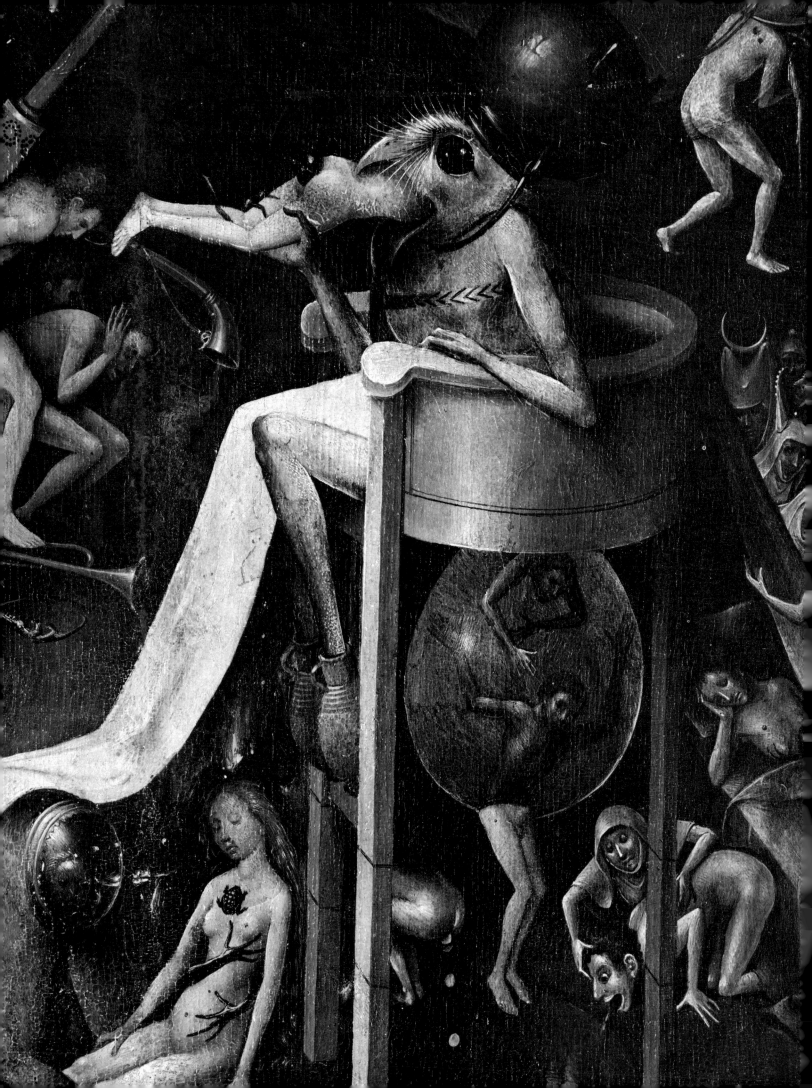

In Bosch's hell all is visual slang, physical representations of the popular beliefs that his damned souls are set to acting out forever and ever. Punishment tends to fit the crime, as in the more orthodox Last Judgments of other artists. Gamblers, drinkers and lechers are recognizable by their torments; a pederast is buggered by a flute; the man being torn by dogs was probably guilty in life of the sin of anger; a miser squatting by a pool of excrement illustrates a still-current Germanic saying about the nature of money, while gluttons swallowed by Satan on his foul throne (as described in *The Vision of Tundale*) become excrement themselves. Sloth, pride, lust, sacrilege—all meet a dreadfully literal justice which needs as little translation now as in medieval 's-Hertogenbosch.

The panel is frequently referred to as *The Infernal Concert,* for obvious reasons. Few of Bosch's images of eternal punishment are actually original with him; but what he does with his nightmarishly oversized musical instruments is utterly, implacably unique. Those who have in a real sense disrupted the harmony of the world are crucified on harpstrings, impaled upon wind instruments, caged inside huge horns, drums and hurdy-gurdies, in hell's counterpart of the celestial choir. (Bosch's ubiquitous bagpipes are also present: their meaning seems to shift from painting to painting, but was always profane.) No one else ever used music like that, not until the Surrealists; and they were just fooling around. As Gibson says:

How different from Geertgen's angelic concert is . . . Bosch's music, where the instruments which gave only passing pleasure in life are now made to give perpetual pain.

(Whether or not the sow-nun cozying up to one of the damned is, as Foote suggests, trying to get him to sign his wealth over to the church, or, according to Orienti and de Solier, offering him a pact with the Devil, one does wonder how Philip II and Fray Sigüenza came to terms with an artist who so regularly installed the clergy, from the pope on down, in hell. Perhaps they told themselves that Bosch was denouncing only false churchmen, depicting them properly as heretical agents of the Devil doing his bidding on earth. As an old rationalizer myself, I don't envy them their task, if that is so: from the early *Two Heads of Priests* all the way to his own fragmentary *The Last Judgment,* there is scarcely a single respectful portrayal of an ecclesiastic to be found in Bosch's entire body of work.)

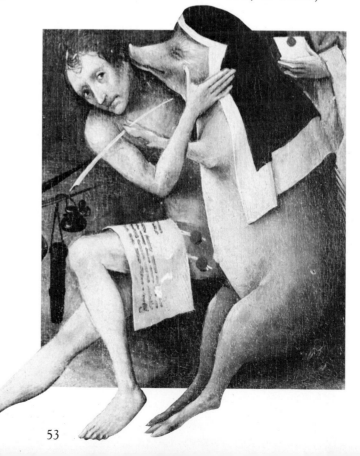

Details from
The Garden of Earthly Delights,
right panel.

Having all through this essay attempted to suggest the many ways in which Bosch could employ conventional shorthand, the fact is that nothing that can be traced, analyzed, categorized—explained— nothing out of folklore or any Gospel of revelation in any manner accounts for such a creature as the Tree-Man. Focal point of the entire hellscape, split stumps of feet like pigs' trotters planted in two broken ships, he looks back over his shoulder with a cold near-smile, passively observing the uses that are being made of his rotting, vanishing body. I was always sorry for the Tree-Man when I was a boy, because he looked even lonelier than the condemned sinners themselves. Bosch has lavished on him all his gifts for making the unreal not only believable but sentient: you can never be sure where wood and flesh begin and end in him, or if they do. I used to wonder, with a child's fierce, easy obsessiveness, whether the Tree-Man could feel the cruel spines of himself that lunged up out of his heels to pierce clean through his eggshell body. You can't be sure. His moon-pale face is often thought to be a self-portrait. I met it regularly for some time in those nights, bobbing gently to the surface of my dreams—lost, drowned, hopeless, fearless, unspeakably free.

In justice to the mystics, it should be mentioned that the Tree-Man—both the figure in the Hell panel and the early drawing that hangs in the Albertina Museum in Vienna—has occasionally been called the Alchemical Man. The whiteness of his body, the bowel-red bagpipes on his head, the "blue boats of destruction" (Tolnay) that support him, all add up, for some, to the traditional emblem of alchemy. Fraenger sees him as the central image of the triptych, the true Tree of Life; while Orienti and de Solier comment at length on the nature of his mysterious headgear, in each version. The drawing represents him balancing a jug and a ladder on an oval tray bristling with nails: this to them is meant to symbolize the cosmic furnace, the ultimate alchemy of the mind. In hell the tray has apparently become a millstone, signifying the bitter weight of mortal knowledge that burdens the Tree-Man forever. There's more to the theory—the great thing about such interpretations is that there's always as much more as you want—but it always amounts to less than Bosch's achievement. It could all be true, and still the Tree-Man would remain a unique and wondrously troubling riddle in the heart of hell.

In both drawing and triptych, the Tree-Man's body houses a kind of forlorn tavern, where solemn nudes sit stiffly waiting for a servant to draw their wine. The innkeeper kneels by the entrance-ladder, looking out with the same vacant despair as Eve. I have a clouded but persistent boyhood memory of reading about the medieval legend of the "Tavern of Lost Souls," where the damned, on their way to hell, were said to be allowed one last moment of drinking, lovemaking and human companionship before eternity slammed shut behind them. Today I have no idea whether or not Bosch was alluding to that old story; but then I was sure he was, and I used to stare myself into the tavern scene, trying to decide if the burly, hooded figure trudging up the ladder was one more lost soul, or—more likely—a demon drover come to herd them the rest of their journey. I imagined myself among them, hearing the heavy steps, seeing the top of the ladder tremble and wondering if it could already be time to go to the fire. The innkeeper would know, but he never speaks or looks at us.

I say *the fire* out of convention; but the overwhelming reality of Bosch's hell—beyond the demons, far beyond the endless torments (which differ only in flamboyant style, after all, from the sober Christian practices of the Inquisition)—is coldness, the perfect, immeasurable cold of the wind between the worlds. The flames catch the expectant eye first: they claw the winter night bloody, setting the dead pools ablaze, screaming through the gutted city in the background as loudly as the damned scream and the demons howl and bray. (As Bosch is the master of making the inconceivable real enough to smell, so he remains king of cacophony—his panels explode with violent *noise*, with insane human racket and yelling, and infernal guffaws.) But I have always felt that in this place even the fires are exactly as cold as the black water—a Fountain of Death now—in which the Tree-Man's boat-shoes are frozen fast, and little figures who once sported in the caressing streams of the Garden now drown forever.

Details from
The Garden of Earthly Delights,
right panel.

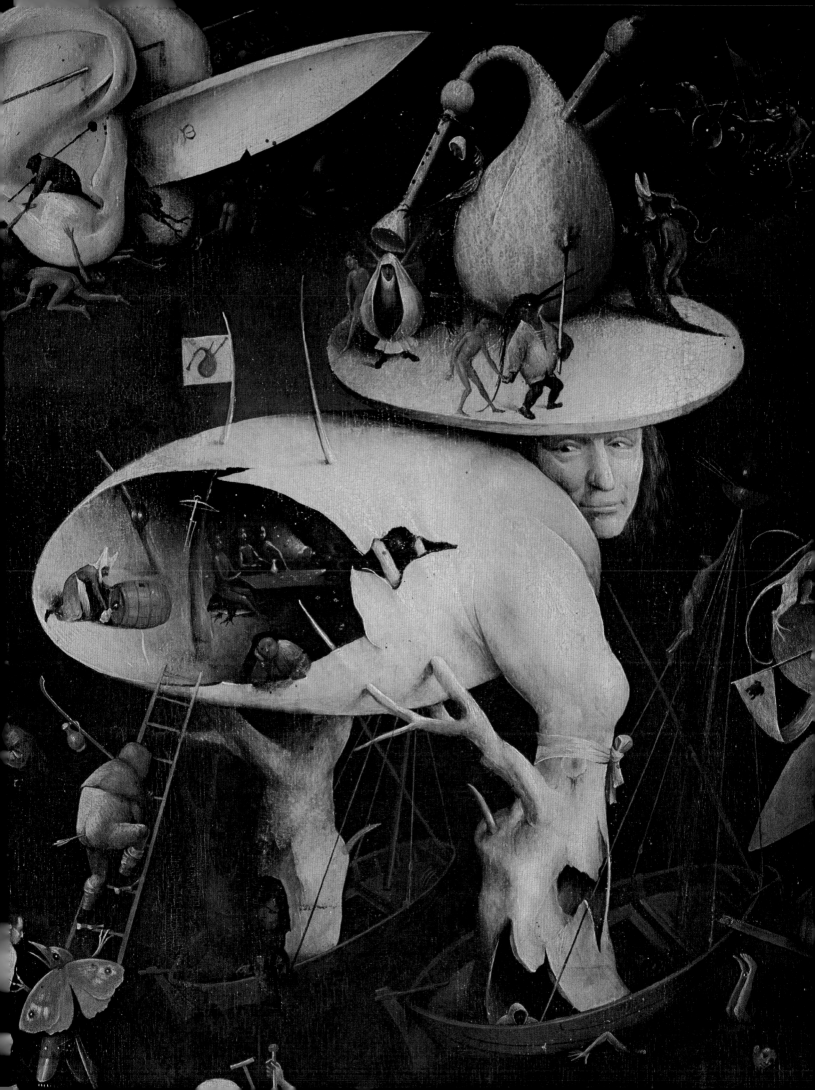

Ernesto Castelli, who sees the great sin of *The Garden of Earthly Delights* as "neglect of one's neighbor in glorifying pure sensation," also writes of the icy ponds of hell as being "the inevitable end of pure sensation." The image is closer to Sartre's *No Exit* than to *The Vision of Tundale*, but I think Fray Sigüenza might have understood.

> *As I see it, the difference between the paintings of this man and those of others is this: the others seek to depict men as they appear outwardly; he alone has the audacity to depict them as they are inwardly. . . . [His paintings are] not absurdities, but rather, as it were, books of great wisdom and artistic value. If there are any absurdities in them, then they are ours, not his; and to say it at once, they are painted satires on the sins and ravings of man.*
> Fray José de Sigüenza

When I finish this I'm going to have to show it to Janwillem van de Wetering, the Dutch writer whom I have quoted earlier. In a more recent letter, he says:

> *I have never ventured to explain Bosch to myself, but all in all I associate him with the best, the glorious, the most wonderful, with great unspeakable mystery and complete freedom. . . . There's joy in Bosch, but of such a level that we are awed. When I saw him first . . . I felt as if all my doubts, protests, misgivings, and misery in the accepted lifestyle that I couldn't join were suddenly answered, as if I finally saw that I had been right in not trusting parents, educators, morals. . . .*

It occurs to me that I have rarely known a writer familiar with the work of Hieronymus Bosch who was not fascinated and affected by it. I think it must be that we recognize the writer's sensibility that lives in those compositions, those swirls and death-marches of narrative, that offhand use of the flat, daily detail in a nightmare context. For us, at least, if not for critics, the mysteries of his symbolism become almost incidental: I have seen poets respond immediately to recitations in a strange language, sensing meaning simply in the way that the alien words slipped and scrabbled over one another. What we feel in Bosch is the same terrifyingly urgent need that has possessed most of us, like one of his demons, for all our various lives: to stop a stranger and tell a story. The tale itself may or may not translate; the hunger can never be disguised.

So we come out of this, at the end, with what is generally a conservative view of an overwhelmingly radical artist—if such nineteenth-century political terms can have the least meaning in the context of medieval illuminations and altarpieces. Given the profound ignorance of Bosch's everyday personal life which, for once, the maven shares with the amateur (astonishing, after all, when one considers how much we know, by comparison, about Dürer,

Detail from
The Garden of Earthly Delights,
right panel.

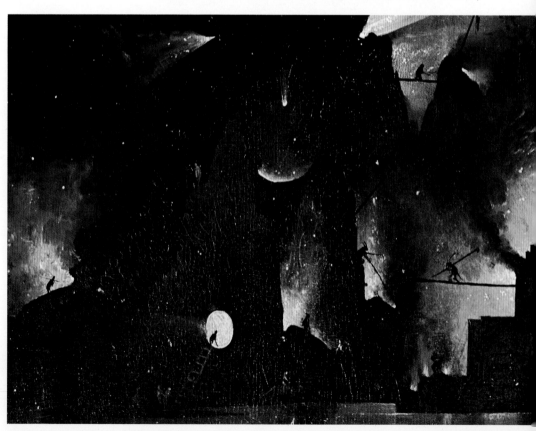

van Eyck, Dirk Bouts), I doubt very much that he was associated in any significant way with any organized heretical sect. I don't believe that his paintings can be explained solely on the basis of an involvement with occult studies so intense that the man wouldn't have had time to clean his brushes, let alone gild a crucifix. I also mistrust any rationale that proclaims, in effect, that Bosch's personal, private demons did the work for him. All artists house demons, even—I'm fairly sure—James Fenimore Cooper. But the id can't draw; the superego doesn't know how to handle light and color; the libido has no sense of composition. Demons matter, but they don't do windows.

What I know about art, like every artist of my acquaintance, is mainly going to work. You go to work, and you try to learn your trade; and slowly you begin to discover just what your particular instrument can do, and what it can't—and what it can *almost* do sometimes, sometimes. The romantic image of the wild, moon-touched, undisciplined, discreetly tubercular artist, as distinguished from the earthbound artisan, is only a creation of the last two centuries. (I myself think Byron and Shelley consciously invented the whole package, with a little public-relations counselling from Paganini.) But in

Bosch's world, in Leonardo's world, in Shakespeare's world, such a separation did not yet exist. There were masters, schools, guilds, but no Academy; patrons and patron saints, but no foundations; kings, but no critics. It was all art, all *work,* and I have no doubt that Bosch designed the costumes and masks for his Brotherhood's theatrical productions, and played music for their processions, with the same craftsmanship, and exactly the same passion, that he brought to his portrayals of Eden and hell. As van de Wetering says, "Everything was religious then."

Everything was religious. So must dreams have been, of course, in a way I will never be able to imagine. Far more than anything else that I want to know about Hieronymus Bosch, I wonder what he dreamed. I believe, finally, that he painted, not alchemical roadmaps or Kabbalistic minutes of the last meeting, but his own nightmares and daydreams, which were the deepest dreams of his civilization. There have probably been artists like that since the caves, one or two in each generation: somehow commanded to dream for a people in its time, to give a shape and a name to the monsters that exist in the particular darkness of that time. Hieronymus Bosch was such an artist.

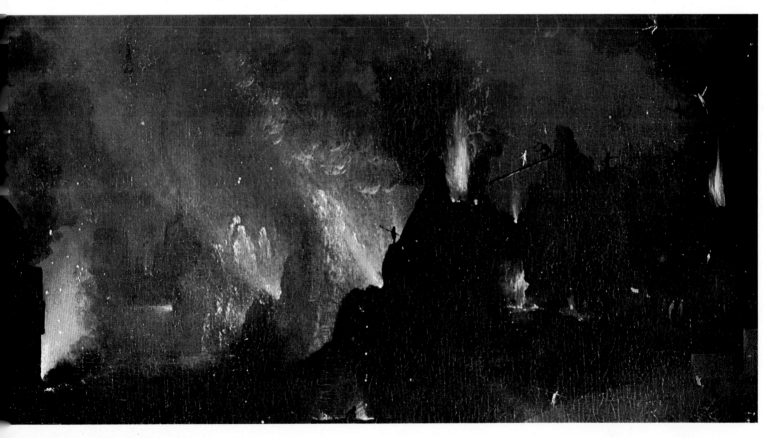

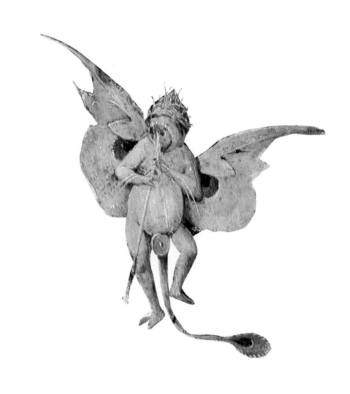

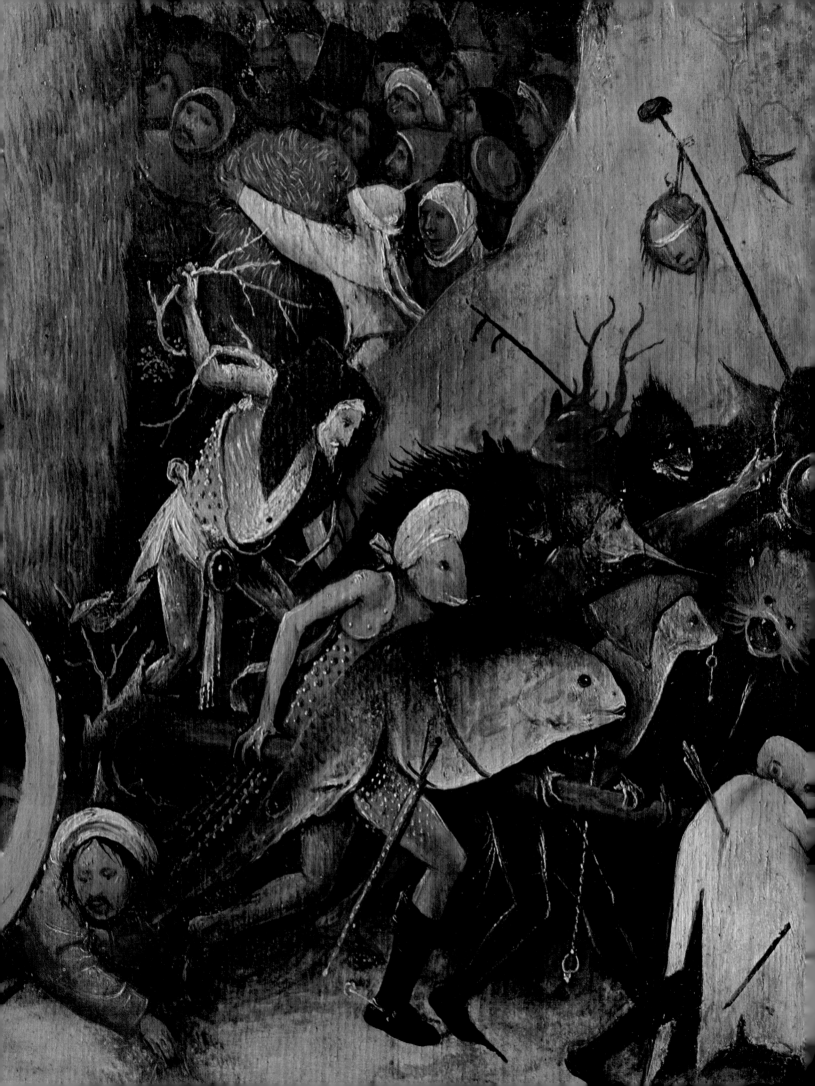

2
Carnival of Folly

The whole world lives in darksome night,
In blinded sinfulness persisting,
While every street sees fools existing. . . .
 Sebastian Brant, *The Ship of Fools* (1494)
The number of fools is infinite.
 Ecclesiastes I:15

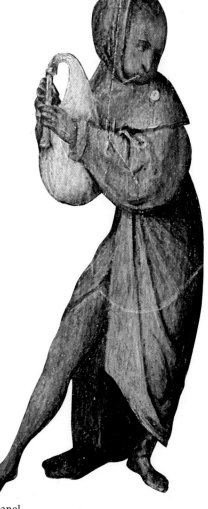

The art of Hieronymus Bosch reflects his culture's pessimistic view of human nature, which was seen as inherently corrupt and largely doomed. Condemned even before birth to bear the burden of Adam and Eve's transgression, Bosch's frail men and women readily succumb to the entrapments of sensual pleasure in its many guises. Lust, vanity, anger, greed—these are among the fraudulent sideshows of the carnival of folly that constitutes human existence.

Bosch's paintings were meant to aid his fellows in coming to grips with mortal folly and its consequences. Like any great artist, Bosch leavened his moralizing with insightful observations of the human condition. His vision was often sad and severe, but tempered with a satirical edge—a highly visual wit that charmed his contemporaries even as it chastized them for their folly.

Every medieval court had a buffoon specializing in merry jokes and pranks. Speaking in riddles, the fool was allowed to poke fun at society without fear or

Details from
The Haywain, center panel.

61

rebuke. He was valued for his scurrilous humor, wild antics, and fantastic, sometimes prophetic, imaginings. Bosch's paintings must have reminded his audience again and again of the satirical court jester, for they are infused with what would have been called fool's wit.

The jester appears in *The Ship of Fools,* perched above the stern of a rowdy pleasure boat drifting aimlessly at sea. He presides over the riotous crew like the Lord of Misrule appointed mock king of holiday festivities across northern Europe. In the celebrated Feast of Fools which flourished in the great cathedral towns, even priests and higher clergy temporarily transferred their authority to a Bishop of Fools and joined in the revels. At the universities, bands of students cut loose, garbed in traditional fool's costumes of ass-eared hoods, bells and baubles. In the Middle Ages, everyone had a chance to play the fool.

One of Bosch's strongest satirical expressions is the ludicrous reversal of values in *The Haywain,* which shows a pompous parade centered on a cart piled high with hay. A substance of supreme value in the painting, the worthless hay induces adulation and violent riots. Grasping humans kill for it, cheat and deceive for it, make love on top of it, damn themselves over it. No social class is exempt: kings and clergy, gentry and peasantry, all live in thrall to the hay's hollow charm. And all the while the cart heads inexorably toward conflagration in the hell scene depicted on the right wing.

The fate awaiting the haywain provides a vivid reminder of the darker side of the jester's imagination, for the ultimate human folly was, of course, sin. Working from the list of most damning (or deadly) sins compiled by medieval theologians, Bosch created a mocking satire on immorality: *The Seven Deadly Sins.* Each of the scenes in this work—painted, strangely, on a tabletop—pictures a type of foolish obsession, from priggish self-admiration to piggish gluttony. The images illustrate how sinful self-indulgence makes one an easy target for the wily Devil and his followers, who enjoy duping unsuspecting marks. Quacks and mountebanks abound in Bosch's world. They confound their audiences with amazing feats of legerdemain, as in *The Conjuror,* or even fake surgical operations; in *The Cure of Folly,* a charlatan pretends to relieve madness by extracting a flower from a lunatic's skull.

Yet folly was too deeply engrained for an easy cure. Only the "Divine Fool"—as Christ was sometimes called for the transcendent folly of his sacrifice—could perform such a miracle. But like the peddler in *The Wayfarer,* Bosch's Everyman is all too likely to take the wrong path. Thus Bosch cautions us: life is a confusion of barkers and buffoons, a carnival of folly in which all the amusements are rigged. Beware!

Details from
The Ship of Fools.

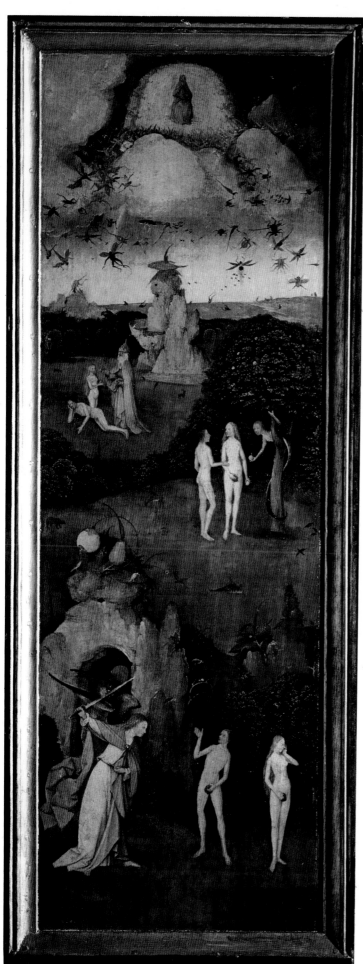

The First Folly

The Talmudists say that Adam lived in Paradise only twelve hours, and account for the time thus:
The first hour, God collected the dust and animated it.
The second hour, Adam stood on his feet.
The fourth hour, he named the animals.
The sixth hour, he slept and Eve was created.
The seventh hour, he married the woman.
The tenth hour, he fell.
The twelfth hour, he was thrust out of Paradise.

E. Cobham Brewer, *A Dictionary of Phrase and Fable*

All human folly traces back to Adam and Eve. Bosch depicts the fateful events in Eden with characteristic vitality in the left-hand panel of *The Haywain*. As God creates Eve from Adam's rib and blesses her, Adam sleeps, unaware of the great gift God is bequeathing him. Bosch shows us Adam and Eve later at the Tree of Knowledge, as an eager and polite young serpent urges Adam to accept the apple. Eve, already clasping her apple, looks at Adam with a mixture of seductiveness and misplaced pride. He reaches out . . . and the consequences loom large in the painting's foreground. A stern, implacable angel banishes them from Eden. They now appear frail and small, and Eve turns away in shame while Adam tries to plead his case. Meanwhile, rebel angels fall from the sky like rain.

The Haywain,
left panel and detail.

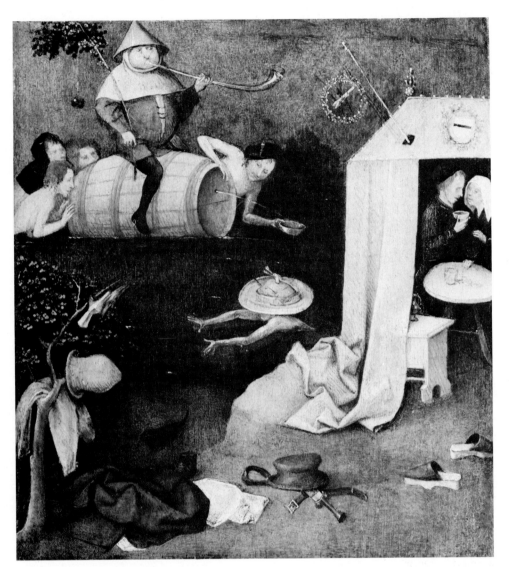

Awash in Intemperance

For wine's a very harmful thing,
A man shows no sound reasoning
Who only drinks for sordid ends,
A drunken man neglects his friends
And knows no prudent moderation,
And drinking leads to fornication;
Through wine a wise man comes to prate
And set a fool's cap on his pate. . . .
Sebastian Brant, *The Ship of Fools* (1494)

Allegory of Gluttony and Lust. New Haven, Yale University Art Gallery, Rabinowitz Collection— Gift of Hanna D. and Louis M. Rabinowitz.

Lust and Gluttony may seen an odd, even humorous, pair of sins to turn up as often as they do in Bosch's art; but these were the vices of which the monastic orders were most often accused during the fifteenth century, and they were more closely matched in the Middle Ages, when large-scale famine and food hoarding were facts of life.

Seated astride a floating barrel of wine, Bosch's rotund master of revels sounds a lusty blast on a long curved trumpet. A naked wader fills his cup from the spout of drink streaming from the bunghole, while some prankish carousers creep up behind the barrel and prepare to flip the fat peasant into the surrounding water—or is it wine? Attached to the tent on the bank is a dangling pig's trotter, a symbol of intemperance associated with Carnival feasting. Within the tent, a couple caught in the throes of lust appears to be engaged in mutual seduction.

The Wayfarer

*I know not rightly who I am
Nor whither I should go. . . .*
Medieval verse

A wandering peddler (sometimes taken to be the Prodigal Son, about to enter his father's pasture) is portrayed in a moment of indecision in Bosch's painting *The Wayfarer*. He casts a glance backward toward the lures of the world and the Devil, as represented by the White Swan Inn: a crumbling brothel where whores wait at the windows, a customer urinates by the wall, and a litter of piglets feed at a trough. His hat and body point forward to virtue, but his eyes are strangely wistful. It is one of Bosch's most haunting images.

Peddlers were typically considered to be lechers and cheats. Although this one seems to yearn for the path of righteousness, the odds appear to be stacked against him. One very ominous sign is the owl peering down from the tree. In the medieval *Romance of the Rose*, he perches in the tree of Fortune, where as "prophet of misfortune and hideous messenger of sorrow (he) cries out and raves." Another harbinger of bad luck—the notorious black and white magpie—can be seen in a cage near the tavern door as well as on a rung of the gate across the path. A final gloomy indicator is seen attached to the basket on the peddler's back: a cat's skin, which in folklore was a bad-luck charm.

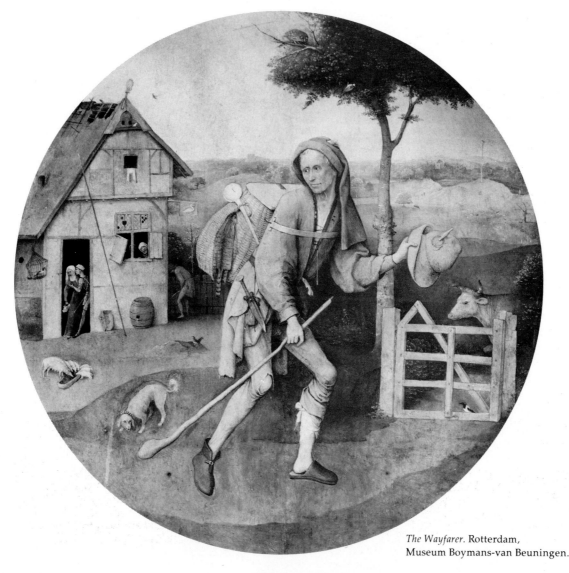

The Wayfarer. Rotterdam,
Museum Boymans-van Beuningen.

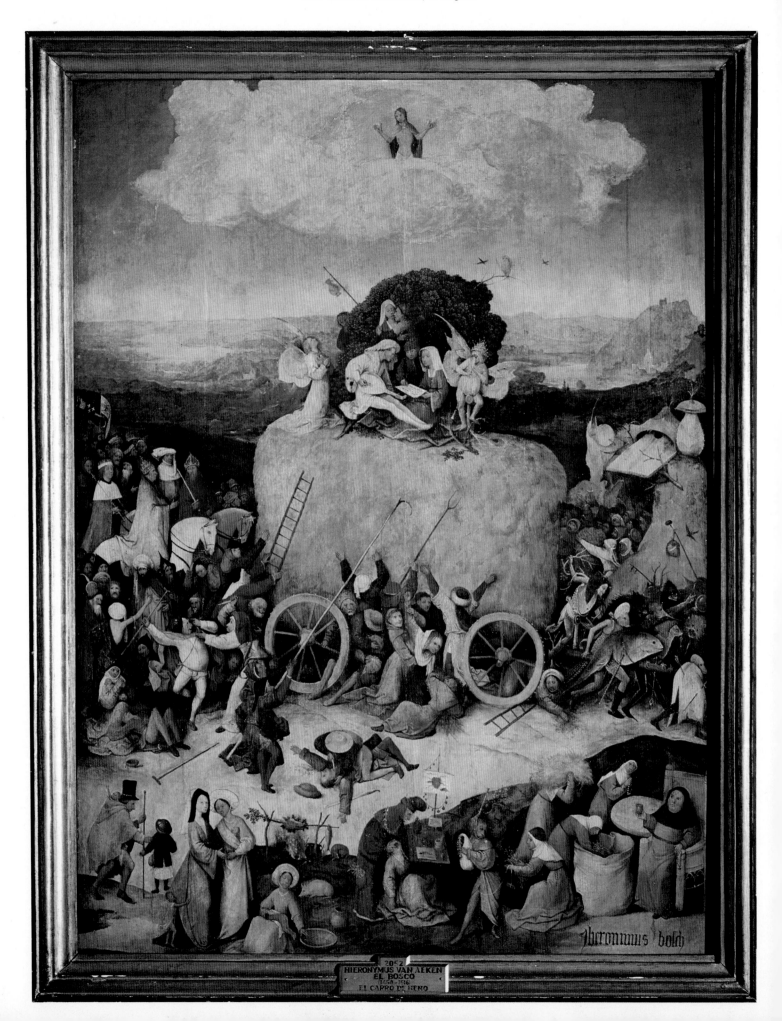

Fool's Gold

Every man is rendered foolish by his wisdom.

<div align="right">Ecclesiastes I:15</div>

"The world is a haystack, and everyone plucks from it what he can get," ran a saying popular in Bosch's day. In *The Haywain*, the artist used common hay, with its golden hue, to lampoon human desire. The hay is like gold; its worth is arbitrary and transitory, but the world is organized around the struggle for it. Even though there is plenty of hay for everyone, people scramble madly after an extra handful, trampling one another, hoarding the tawdry stuff away. Poor peasants, who can grasp little of the prized hay, are crushed under the wagon as it rolls on. This fool's gold, and the frenzy it provokes, brilliantly express the vanity of earthly riches, which are, ultimately, *al hoy*— "all hay," or nothing.

Hay Kings on Parade

Behind the haywain trails a large group of dignitaries on horseback led by a pope, an emperor, and a king. These worldly powers make the occasion an excuse for a grand procession. Bosch satirizes the love of pomp and display that characterized his era, particularly the custom of staging a magnificent triumphal entry whenever a ruler visited a city. Here the potentates are duped into believing that the haywain is meant for their own glorification. Little do they relize that demons are dragging the infernal parade float straight for the open gates of hell.

Bosch seems to suggest that these serene authorities aid the demons through their indifference to starvation, misery, and violence. Indeed, the officials are shown to have abdicated true leadership in favor of a venality far graver than the greed of common men.

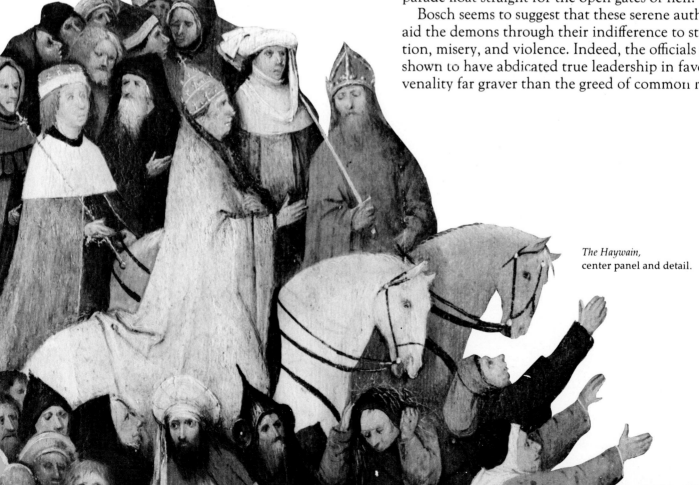

The Haywain,
center panel and detail.

Hayride to Hell

Bosch constantly represents lust as the taproot of all other sins, so it is natural that lovers should crown his haywain. A dapper troubadour serenades one young couple with his lute. They attentively follow the melody on a sheet of music; a clump of bushes behind them partially conceals embracing lovers and a furtive peeping Tom. An angel prays piously for the souls of the foolish pleasure seekers. Alone among the figures in the panel, his eyes are raised towards Christ, who appears above in a cloud of glory, his hands thrown up in despair. The jovial devil at right celebrates victory by piping a lusty tune through his long snout.

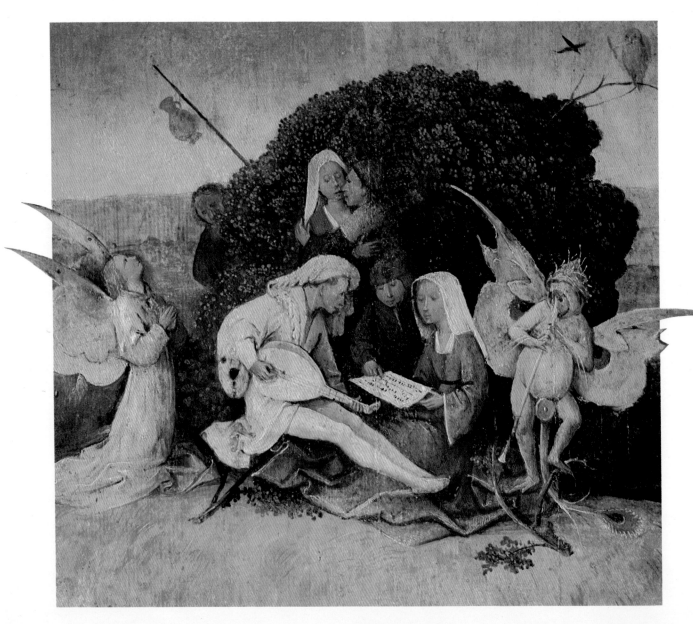

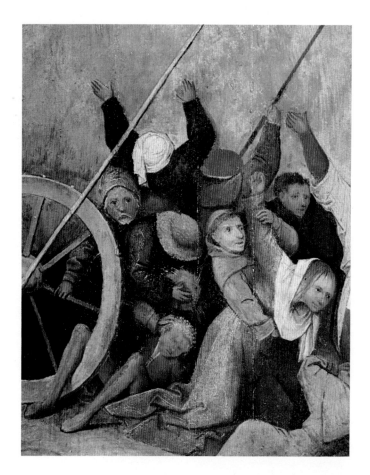

Clutching at Straws

To "drive the haywain" with someone meant to mock or cheat them. Bosch is making it clear that people will stop at nothing to possess more of the ephemeral golden hay than their neighbors. Their greed leads to envy, violence, even murder. One man cuts another's throat on the ground, while two other men nearby are trying to snatch hay over the heads of the poverty-stricken people being crushed under the wheels. Unaffected by this literal "fighting over straws," the haywain moves along, relentlessly drawing humans down the path to hell.

Details from *The Haywain*,
center panel.

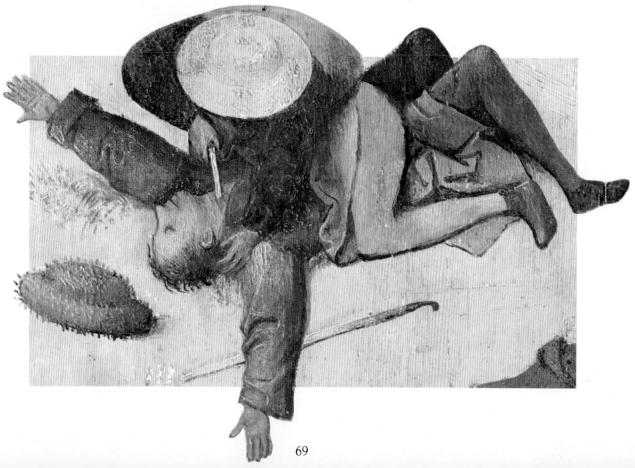

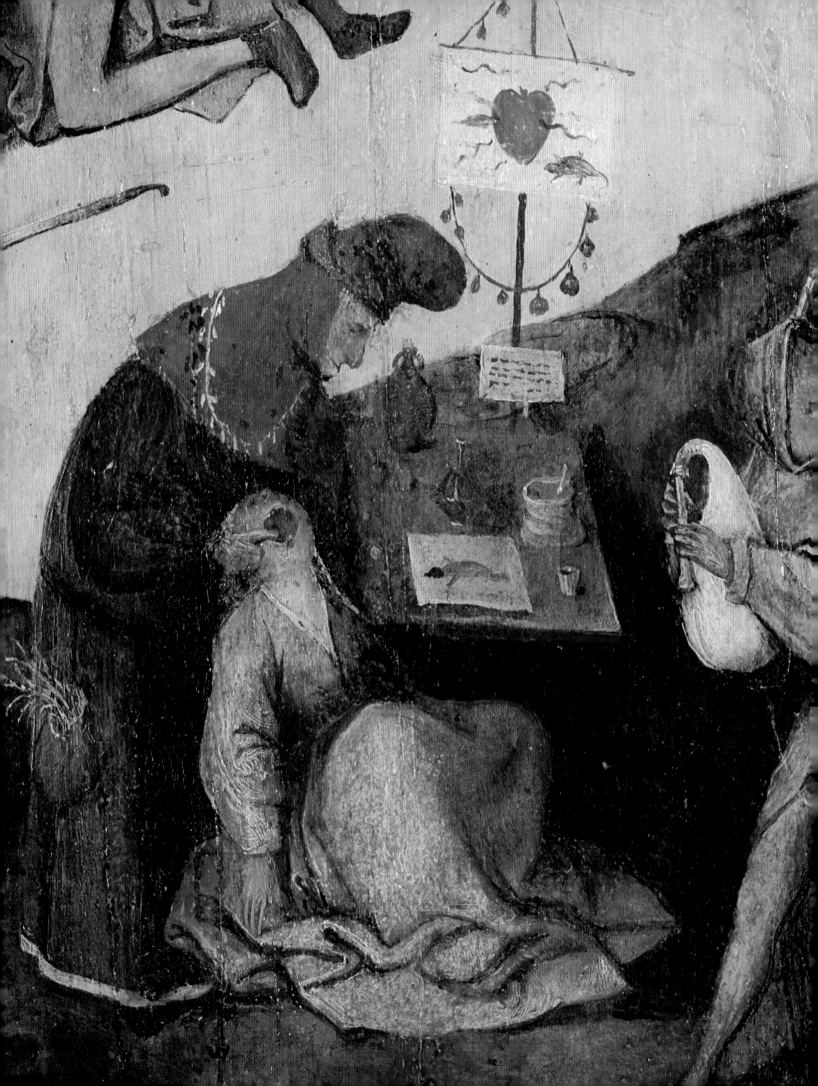

Painless Extraction

A quack dentist fakes an operation on the mouth of a well-drugged female patient. His purse is stuffed with hay, indicating he is extracting a hefty fee. The red heart on the dentist's banner tells us he also has amorous designs on the naive young woman.

Churchly Hay

The clergy is clearly no exception to the mad rule of the haywain. In the foreground, two nuns stuff a huge sack with hay for the benefit of an already fat monk. He ignores the warning prayers of the nun who displays her rosary before him. With his ego puffed up like the sack, the overstuffed abbot complacently drinks the sacramental wine as he supervises his steady accumulation of wealth. Like others in the late Middle Ages, Bosch satirized corruption among the clergy; here he evokes both the selling of churchly favors and illicit relations between monks and nuns.

Details from *The Haywain,*
center panel.

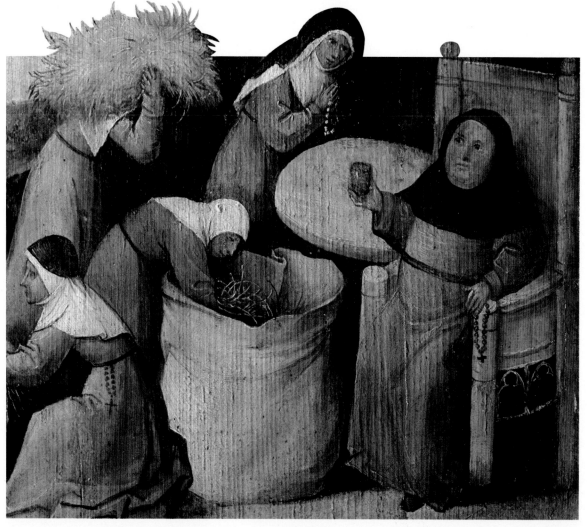

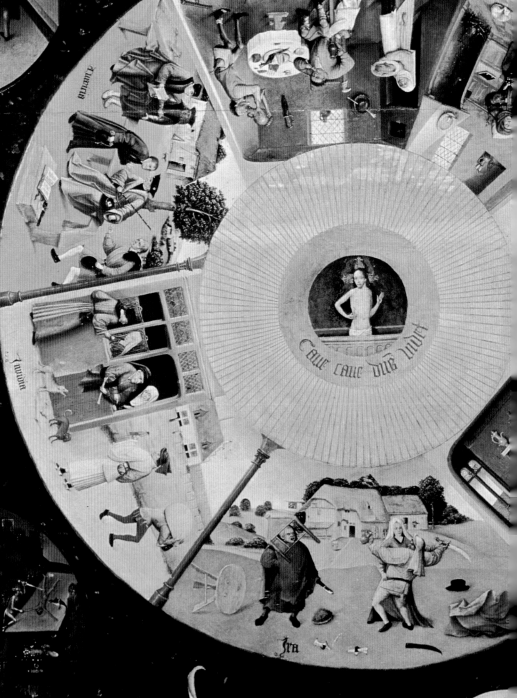

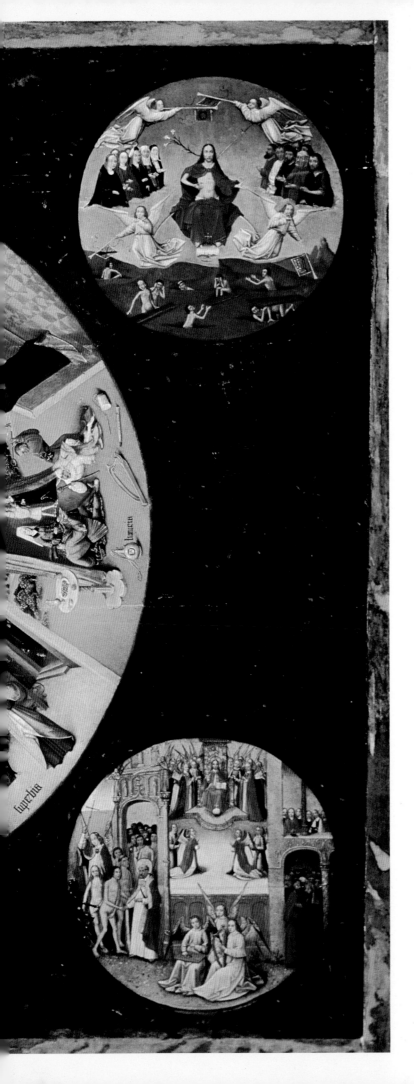

The Seven Deadly Sins

*O how marvelous is thy glance, my God.
... How fair and lovely it is unto all that
love thee! How dread it is unto all them that
have abandoned thee, O Lord my God!*
Nicholas of Cusa, *Vision of God* (1453)

Bosch's table-top clearly represents the Eye of
God, from whose pupil Christ looks straight at the
viewer, embodying the legend beneath: *"Beware, Be-
ware, God Sees."* Extending outwards are rays of
golden light, symbolic of divine illumination and
omniscience. The table was presumably designed for
religious meditation. To encourage the Christian's
self-examination, the seven deadly sins are depicted
in a circle of small, straightforward scenes around the
outer ring of the Eye. The implication is twofold:
God sees the sins taking place all around the earth at
every moment, and he also sees the viewer, in whose
conscience is mirrored the same evils portrayed on
the table. Small circles at the corners frame re-
minders of death, the Last Judgment, heaven, and
hell.

The Seven Deadly Sins.
Madrid, Museo del Prado.

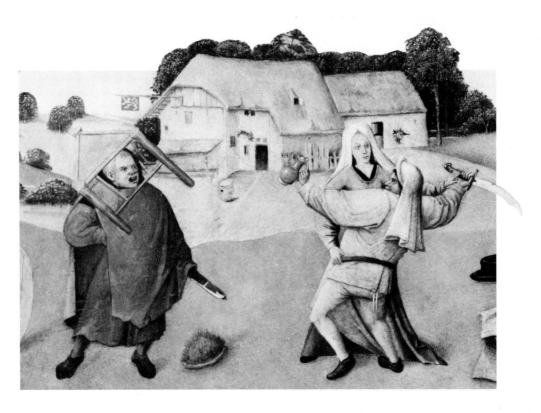

Anger shows a brawl between two drunks in front of a tavern. A barmaid tries to restrain one of the men, who has a drawn sword in one hand and jug of beer in the other. He reels about tipsily, perhaps distracted by her charms. His opponent brandishes a three-legged barstool and snarls drunken threats. Bosch illustrates two aspects of a vicious syndrome: how alcohol often induces anger, and how both combine to cause temporary insanity.

Gluttony rules this hearty peasant household. The pot-bellied father gnaws at a pig's trotter, a hefty jug of beer in one hand. The boy—who looks equally well-fed—reaches up voraciously for more helpings from the table. A plump hausfrau brings in yet another course, a plump roast goose, while more food is seen by the fire. Meanwhile, a poor relative swills a huge pitcher of drink. His emaciated appearance suggests that his gluttony is easier to excuse, although it dominates him as totally as the others.

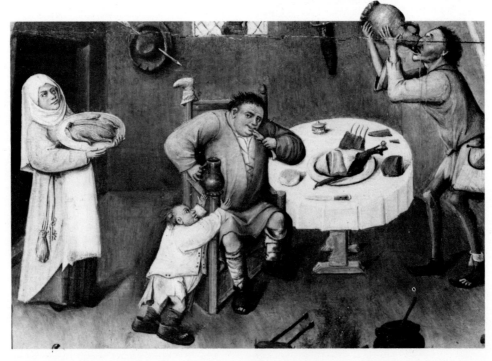

Pride shows a woman in her dressing room trying on a new hat. It is the popular "bicorn" headdress: a linen wimple held up by two projecting horns of hair. Late medieval preachers regarded this fashionable style of millinery as a sign of feminine ostentation. The woman admires herself in a circular mirror held up by a hideous demon, who mocks her headdress with the one he wears so ludicrously.

Lust is staged in a verdant pleasure park decked out with a gay pavilion. An ass-eared jester carrying his fool's bauble entertains a pair of lovers with double-entendres. The suitor lounges languidly on the rich expanse of his lady's robe. He passes her a cup of wine while she eyes him provocatively. In the recesses of the tent a foppish libertine makes a pass at a sumptuously robed lady. The platter of ripe cherries on the picnic table evokes the sweet pleasures of lovemaking. Lust's painful side is signalled by the ruffian about to whack the fool with a long wooden spoon—a sign of dissipation and debauchery. The harp in the foreground was considered a female symbol; the flute a male one.

Details from
The Seven Deadly Sins.

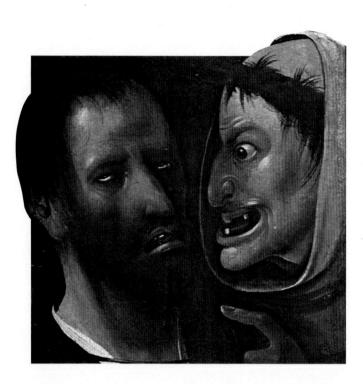

Christ Carrying the Cross

Rage, madness and pure pleasure in the sufferings
of others twist the truly demonic faces of Christ's
tormentors. Two goggle-eyed executioners grin hun-
grily at the bad thief, who faces them with a certain
admirable defiance and contempt. The good thief,
ashen with terror, is caught between a grotesque old
Pharisee and a hideous, ranting Dominican monk.
Christ, borne along by the rush of the mob, seems to
have escaped them already, into heaven, or into
himself. He is wrong about this lot of humans any-
way, Bosch is saying, as clearly as he ever said
anything. They know what they do.

Christ Carrying the Cross.
Ghent, Museum voor
Schone Kunsten.

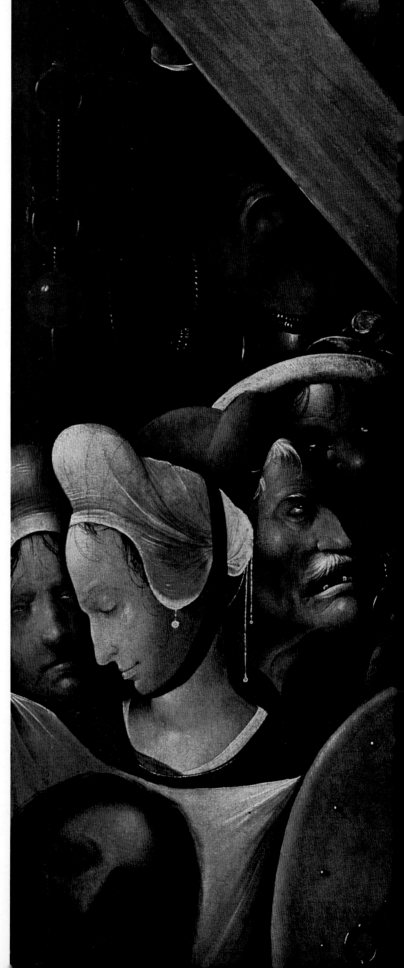

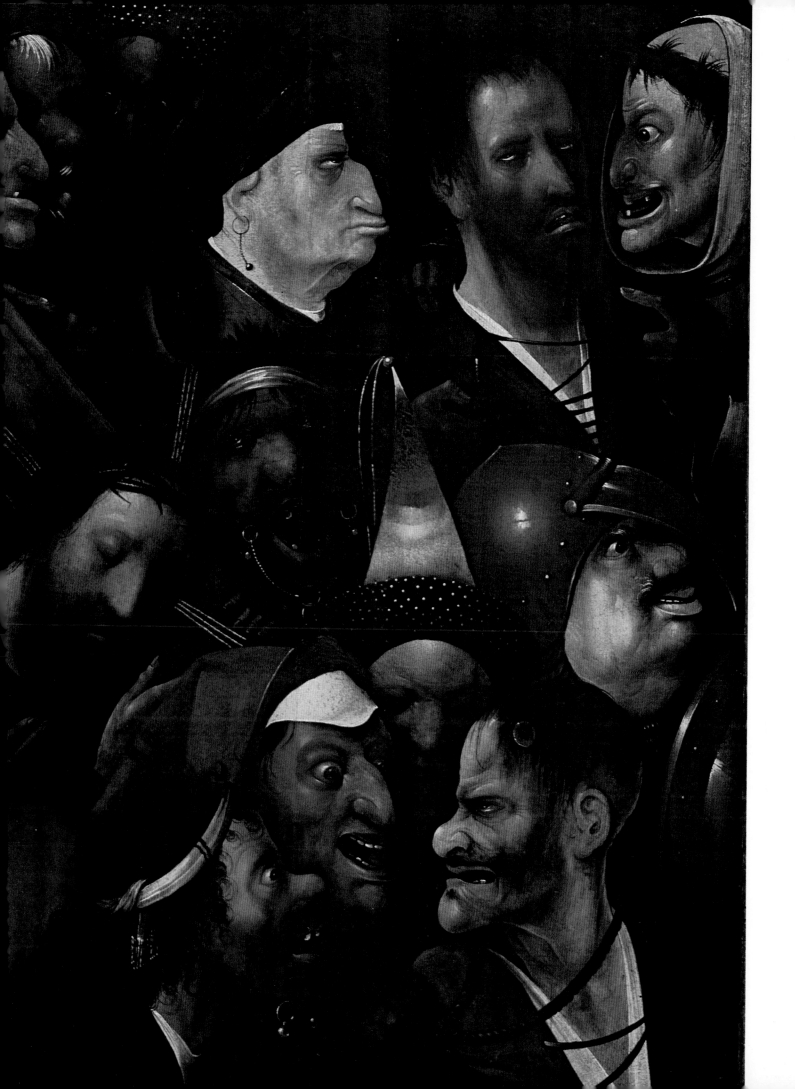

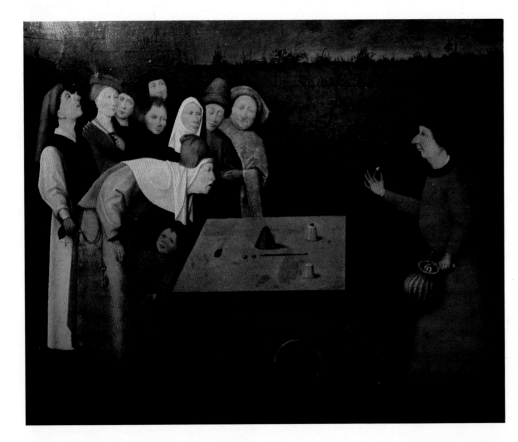

The Conjuror.
Saint-Germain-en-Laye,
Musée Municipale.

Ship of Fools

We travel around through every land,
We seek through every port and every town,
We travel around with great harm
And cannot reach
The shore where we should land.
Our journeying is without end
For no one knows where we should land
And has not one peaceful day, one peaceful
night.
To wisdom none of us pays heed.
Sebastian Brant, *The Ship of Fools*

A Medieval Sting

Now you see it,
Now you don't.

Aided by such time-honored patter, a conjuror dupes his credulous audience with the proverbial cup-and-balls trick—the old shell game, depicted in *The Conjuror.* A foolish old man leans forward in disbelief, and suddenly the magician makes frogs jump out of his mouth. The dumbfounded rube seems to take no notice of this; nor is he aware that his purse is being stolen by the conjuror's sly accomplice, who pretends to gaze stupidly up at the sky. The child holding a pin-wheel might well be marveling at the gullibility of his elders. In the upper left-hand corner, an earth-like globe spins round and round, suggesting the universal nature of human foolishness.

Bobbing around at sea in a round-hulled tub, this raucous group of revellers has won a place in the Orgiasts Hall of Fame. The Ship of Fools in the painting of the same name will never make it back to shore, for its mast is a May Tree and its rudder a giant sauce ladle. But who cares? Certainly not the quintet of merry songsters, led by a monk and a lute-playing nun. The object hanging between them like a primitive microphone is a tempting pastry eaten at Carnival time. In fact, Bosch's memorable ship may derive from a popular club of Carnival merrymakers in the Netherlands, the Blue Boat (*Blauwe Schuit*).

Perched above the stern is a fool lost in his cups. Perhaps he has a woozy inkling that this floating Bedlam is drifting toward Satan's harbor. The signs are clear, including the ominous owl perched on the tree-mast, and the crescent of Islam on the ship's pennant. These hapless sailors—drunken, lustful, gluttonous, blasphemous—are surely caught in devilish currents. Bosch poses the question: Are we all in the same boat?

The Ship of Fools.
Paris, Musée du Louvre.

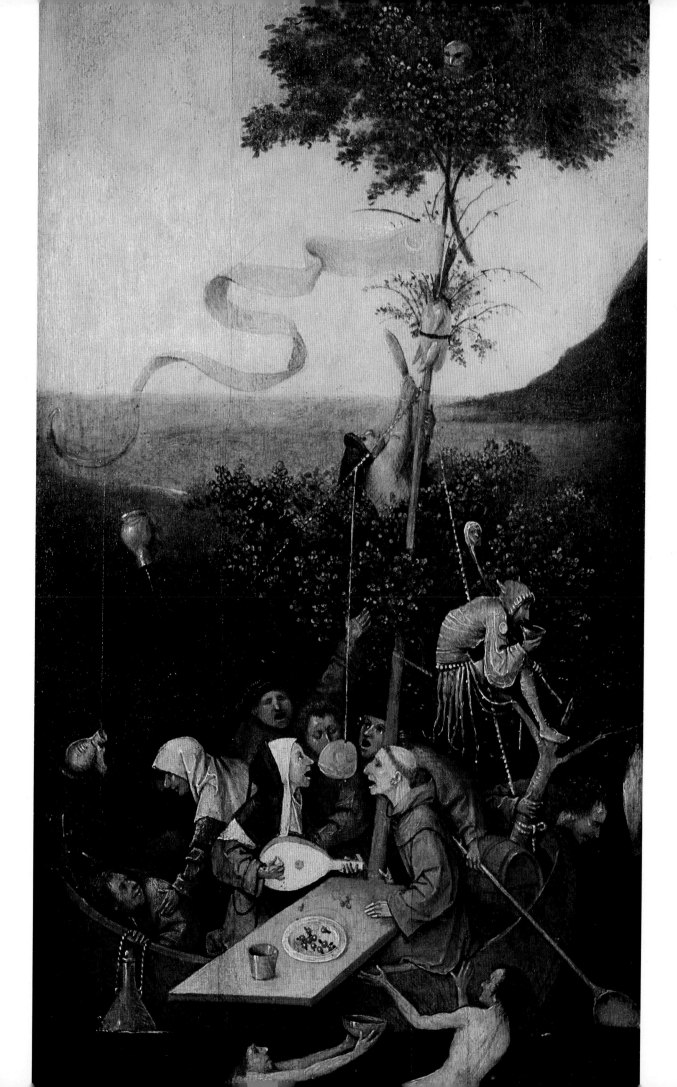

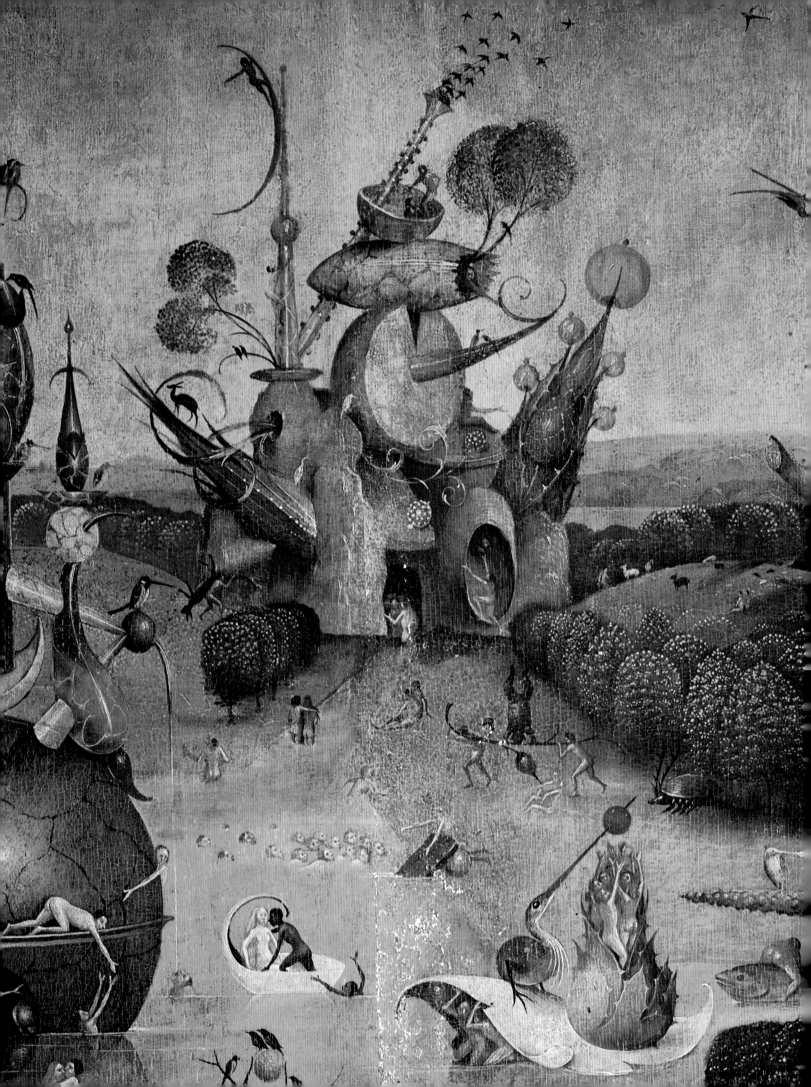

3
Earthly
Delights

At first glance, the Garden of Earthly Delights indeed looks like a reborn Eden where naked men and women sport together in celebration of limitless, unending sensual pleasure. But Hieronymus Bosch's world was obsessed by the skull beneath the skin: beauty was only the transient mask of decay, and even the most innocent sweetness might be the Devil's lure. The Garden's dazzling colors and joyous appearance are meant to trap the viewer in his or her own desires, just as it has trapped those who dwell therein. If we look closer, what appears to be enjoyment soon comes to seem more and more uneasy, even frightening. The humans' frantic, mindless pursuit of food and sex shows that they are being swallowed up by their unbridled appetites. Just as a mollusk shell snaps shut on a pair of lovers, so sensuality has trapped all these souls.

All illustrations in Chapter Three are details from the center panel of *The Garden of Earthly Delights.*

In the Middle Ages, the sex act was seen as proof of the human fall from the angelic state. At best it was a necessary evil; beyond that, a deadly sin. Lust is literally the Garden's central transgression: in the very middle of the scene, a horde of excited men ride phallic animals around naked, bathing women. The berry was a common metaphor for sensual indulgence; those who aren't gorging on it or hungering for it are coupling numbly together. Lust lies at the root of all other sins, as Bosch seems to tell us; so acts of greed, violence, and jealousy may also be seen in the Garden of Earthly Delights.

The Garden's inhabitants have built high, bizarre towers in their passion to reach heaven, or to enjoy heaven on earth. The great park is also full of planet-like globes enclosing lovers, briefly the gods of their private worlds. But these spheres are fragile, often cracked or peeling open; merely a temporary refuge from the Garden's erotic madness. We peer into these natural shelters feeling like voyeurs spying on ourselves—feeling like Bosch's God surveying humankind.

Bosch's moralizing is tempered by the enchantment of his art. We are invited to enter and explore a world teeming with fascinating beings and objects, bewitching colors and textures. The artist's superb technique permitted him to capture in paint what his mind's eye conjured up. In addition to his terrifying demonic imagery, Bosch created images of considerable charm and appeal, exemplified by the luscious fruits, sparkling gemstones, and diaphanous orbs of the Garden. Without accepting it at face value as a visual ode to human sensuality, the modern viewer, like his pious medieval counterpart, takes leave of this fantastic preserve with an enhanced perception of earthly beauty, as well as earthly desire.

Quarrel in a Shell

Three naked men creep dazedly from the empty husk or rind of a large fruit: one sprawls on his back, perhaps only exhausted, perhaps dead. According to Dirk Bax, Bosch here plays on the medieval Dutch word *schel*, which could mean both a rind and a quarrel—to be in a *schel* was to be in conflict with an adversary. A violent struggle to the death, or merely the languor following a homosexual love-bout? Bosch would have regarded either as the Devil's handiwork; and the bird who clings upside-down to a segment of the shell is probably another of his demons, secretly and greedily nourishing itself on human wantonness.

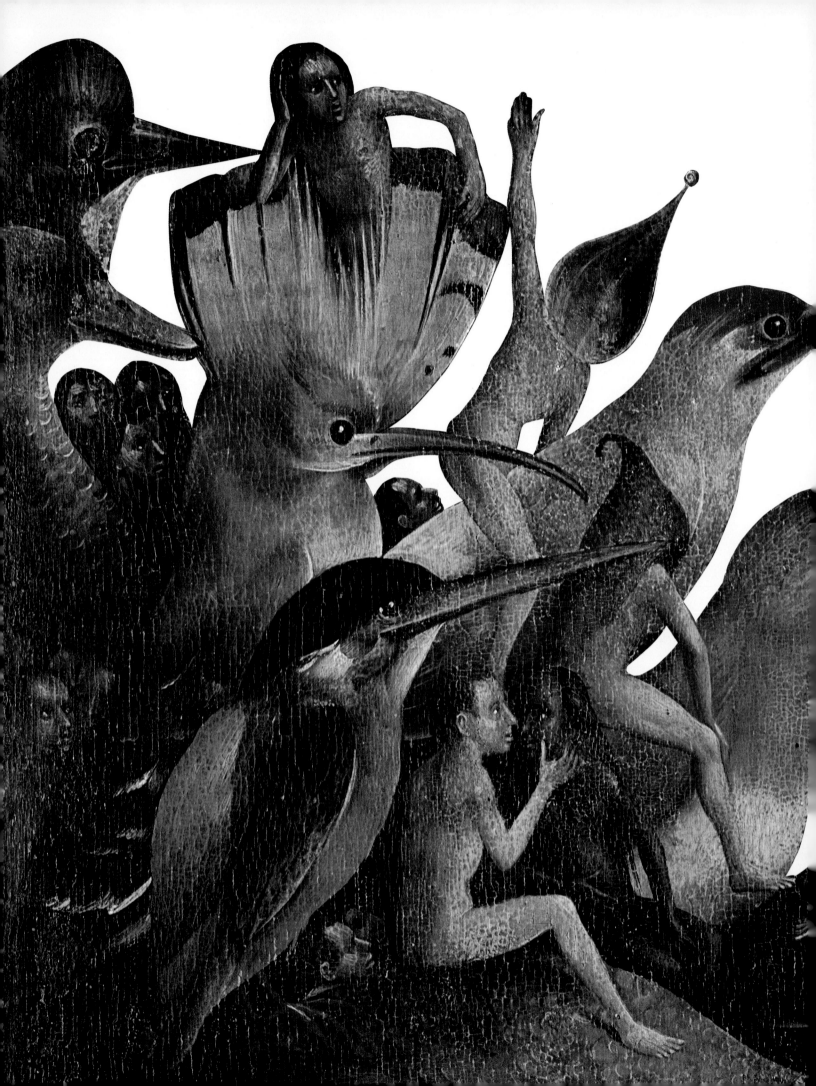

In the Garden of Earthly Delights, men and women have failed to master nature. Just as their own natures dominate them absolutely, luring them into sinful acts which can only lead to damnation, so too are they the weak prey of the external world. This is nowhere more evident than in the portion of the central panel where a variety of birds dwarf the fragile humans who surround them. At first glance these birds may well appear benevolent: one man rides on the back of a huge goldfinch, smiling dreamily as the bird extends a juicy berry to three men who hungrily try to seize it with their mouths.

As we look more closely, however, these expressionless creatures with their sharp beaks and unblinking black eyes begin to appear strangely menacing, as though they are waiting patiently, silently, for the appointed moment when they may turn and attack these foolish little people. Like most wild animals in Bosch's uneasy time, beaked creatures were generally considered at least potential allies of the Devil, himself depicted as a hawk-headed monster devouring the damned in the Hell panel. Birds represented diabolical rapaciousness and pride—expressed here by their giant size, colorful plumage, and showy crests. Symbols of the unsubjugated natural world, they serve as eerily ominous reminders of the unruly passions of humankind.

Birds of Ill Omen

And God blessed them, saying to them, 'Be fruitful and multiply, and replenish the earth and subdue it; and have dominion over the fish of the sea, and over the fowl of the air, and over every living thing that moveth upon the earth.'

Genesis I:28

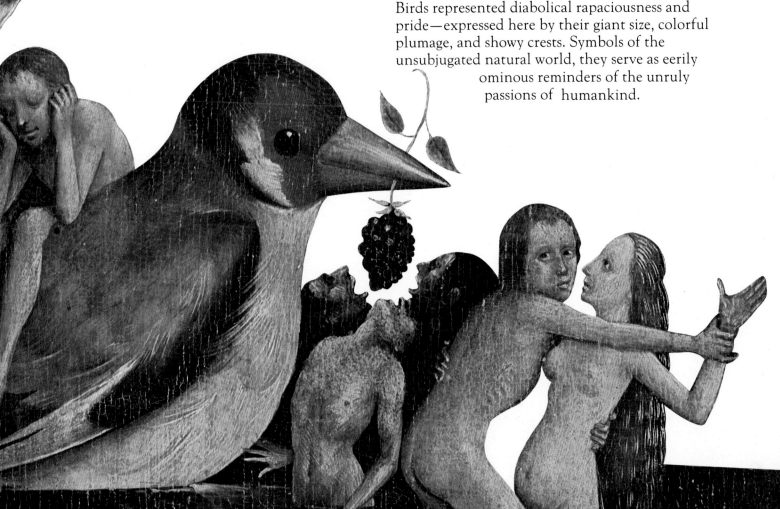

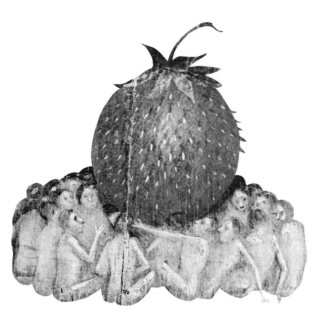

The Strawberry Cult

A throng of men gather worshipfully around an enormous strawberry. These men merge to become merely a swarm of bodies and heads; having lost all individuality, they resemble insects in their ceaseless quest for satiation, both physical and sensual. In medieval Dutch, the strawberry was called *erdbere* (earth-berry) because it grows close to the ground. The Dutch name was one reason for the fruit's identification with earthly, sensual passions. Another reason might be the plant itself, whose runners wander away in all directions, just as humans stray from the path of righteous behaviour.

Nearby, another featureless horde rushes from the Pond of Lust into an empty eggshell. The shell symbolizes the futility and barrenness of their self-consuming desires. These frantic men are *doren*, a Dutch word that could mean both "yolks" and "fools."

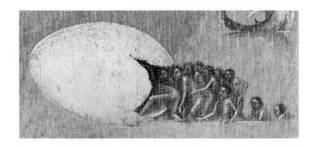

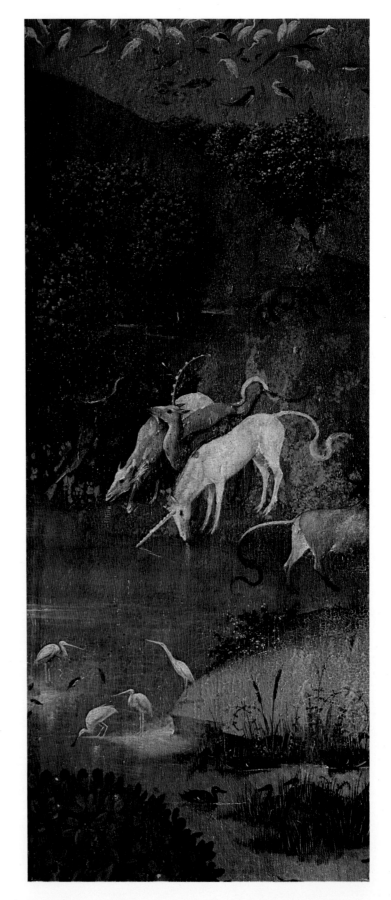

The Torture of Tantalus

Tantalus, king of Phrygia, once dined with the gods on Mount Olympus and, when they weren't looking, stole their nectar and ambrosia. Tantalus then invited the gods to dinner at his earthly castle. He had devised a plan to test their divinity: he served them the body of his own son, reasoning that if they were true gods they would know they were eating human flesh. For these crimes Tantalus was cast into Hades, where he was condemned to stand waist-deep in the middle of a pool, surrounded by overhanging trees laden with delicious fruit. He was tormented by thirst and hunger, for when he reached for the fruit it would evade his grasp, and when he leaned down to drink the water it would recede. For his pains, the wretched king is represented in the language by the word "tantalize."

In the Garden of Earthly Delights there are many Tantaluses: we see one such group—immersed in water, like the king himself—greedily devouring an immense strawberry. The berry is like the nectar of the gods, because it represents the elusive sensuous pleasures that humans yearn to enjoy. But those partaking of it will soon be sharply reminded of pleasure's fleeting nature; floating by in a boat formed from the proverbial apple of temptation are two lovers who are about to snatch away the forbidden fruit.

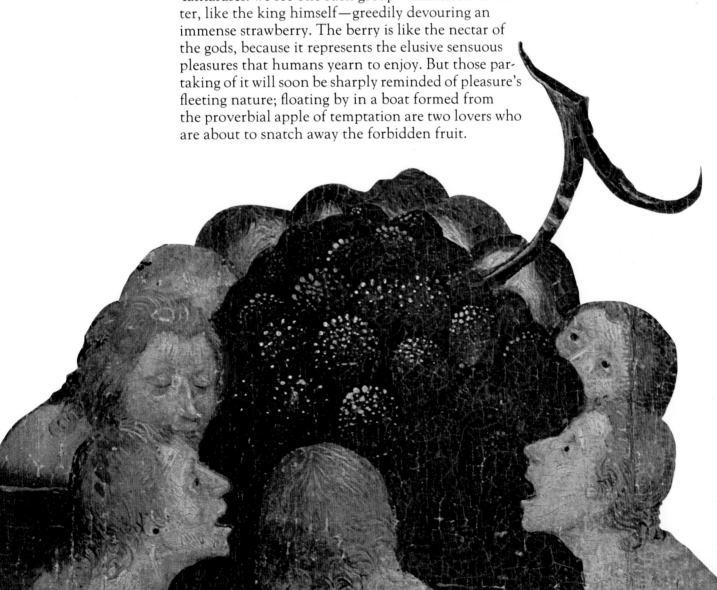

You Are What You Eat

In fifteenth-century Dutch, "to pluck fruit" meant to make love. These men take gluttonous, obsessive pleasure in sex, here represented by the berry. The man in the center holds the succulent fruit before his parted lips and glances seductively at the viewer, inviting us to join him in the garden. Another man gazes in fascination as little berries spill from the bell of a larger berry, like coins from a slot machine. The third man smiles sheepishly at us while he devotedly hugs his own overgrown berry, gnawing on it like a baby chewing on his blanket. The leaves sprouting on his head show us that he is so immersed in berry pleasures that he is slowly losing his human form.

This is among the most recurrent of Bosch's themes: one's humanity—or one's soul—is dreadfully easy to lose, and what we abandon ourselves to possess, we become. Bosch lived in a time of violent, passionate fantasies, as do we; and his Garden is haunted by human beings in various stages of being transformed by their own hungers. William Blake, two centuries later, may have found all beauty in "the lineaments of gratified desire," but for Bosch the inevitable end of such self-absorption is the silent stare of the Tree-Man in the icy, howling night of hell.

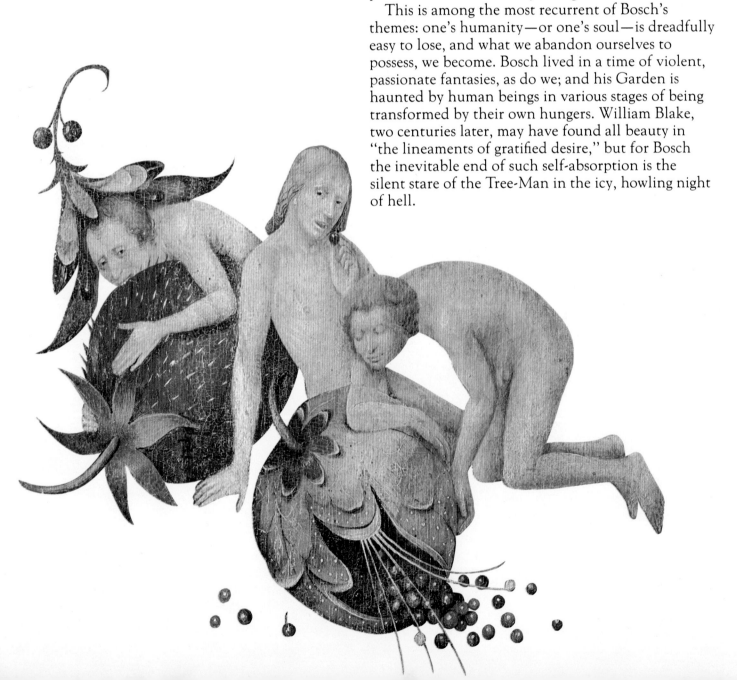

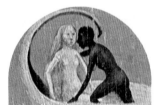

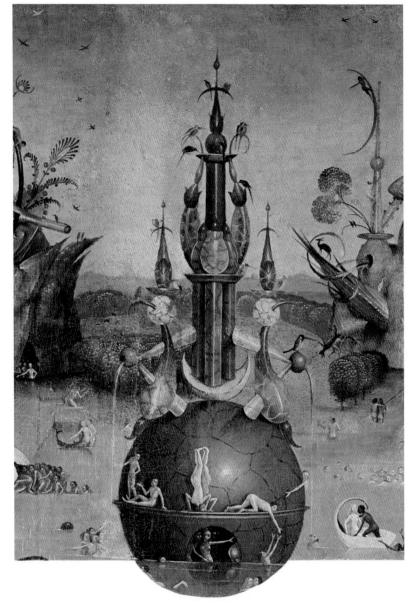

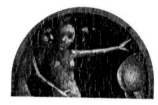

Pleasure Makes the World Go Round

The Fountain of Worldly Allure stands in the middle of the Pond of Lust. The base of the tower looks like the earth's globe, but it is cracked and hollow, perhaps suggesting the ruinous sham that humans have made of their world. Along the equator men and women frolic, holding out their hands to help other swimming sinners aboard; a pair of lovers balance on their heads, perhaps signifying that there is no virtue—no sense of right-side-upness—to be found here. In the underworld hollow of the tower lurk the adulterers. We see a man's naked bottom, and another man reaching for a woman's genitals. Gleaming pink horns of cuckoldry sprout from the top of the tower.

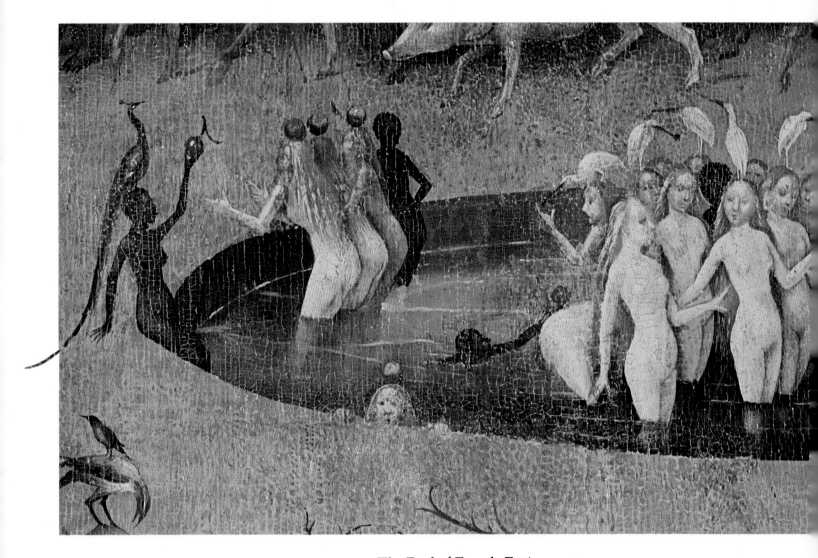

The Pool of Female Enticement

In the center of the Garden lies the Fountain of Youth where naked women bathe enticingly, exciting the men who ride thunderously around them on wild animals. The women are attended by white spoonbills, crows and peacocks, birds that symbolize vanity and sensual enjoyment. Some of the women hold apples or cherries in their hands or balance them on their heads, revealing their kinship to Eve. The Middle Ages saw women simultaneously as a goddess at the castle window, to be worshiped and courted with passionate formality, and as the Fall incarnate, responsible by their very nature for leading men into lustful or adulterous crimes. Here Eve's sin is repeated *en masse*, and the fact that this scene occupies the center of the Garden seems to define lust as the passion which lies at the heart of all the other evils cultivated there.

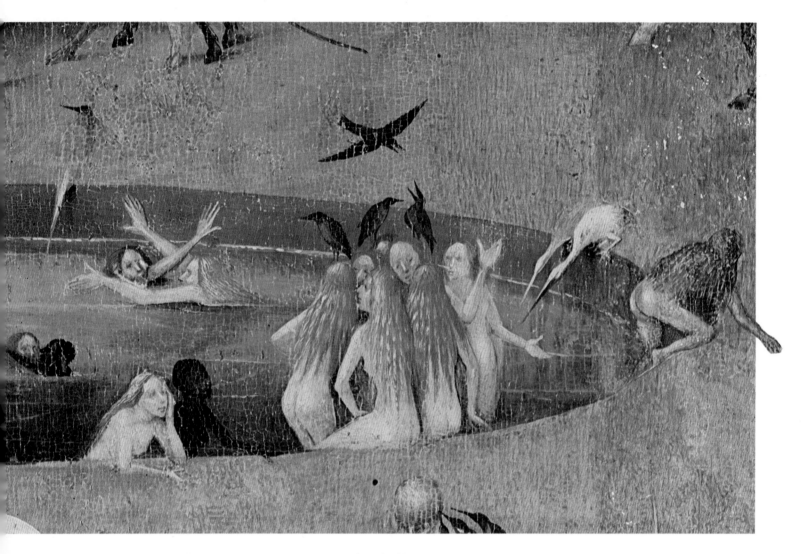

The Shell Game

At the Carnival of Ghent in 1538, the King of
Fools ordered the Queen of Fools to present him with
a carp and a pail of mussels every year. The mussel is
carnival food, often found alongside images of play-
ing-cards and dice, traditional symbols of human
revelry and folly, especially during Shrove-tide. Here
a pair of lovers have found shelter in a giant mussel
shell. The shell is an appropriate haven for them
because *mossel*, in Bosch's time, also meant *vulva*. It
was a common medieval belief that witches could sail
the seas in mussel shells. In this case, the lovers are
carried through the air in their sensual vessel, while
the man who bears them appeals to the viewer with
pained eyes. The lovers' sin weighs heavily upon
him, as the cross weighed on Christ. Meanwhile, one
lover tries to pry the shell open with his hand, but to
no avail: the shell is snapping shut around them,
forever trapping them in their pleasure bed.

Manic Merry-go-round

Naked men ride a wild cavalcade of animals around the pool full of sultry female nudes. Galvanized by lust, the riders show off for the women with a variety of antics. They cavort atop a Boschian menagerie that includes common farmyard beasts as well as the lion, panther, camel, and griffin, a fabled creature from Greek mythology with an eagle's head and wings on a lion's body. Ridden without bridles, the animals represent unrestrained sensuous passion—sometimes referred to as bestial love. Bosch's circular procession parodies the circus spectacles of pagan Rome: especially the fabled Circus Maximus, where as many as a hundred chariot races were held daily, and exotic species fetched from farflung reaches of the Roman Empire were paraded.

Some of the men glance warily at the porcupine enclosed in a bubble. It is a symbol of the Devil, because its needles are difficult to extract, just as evil ways are difficult to mend. The riders may be drunk as well as aroused: the spoonbills represent unchastity and addiction to drink, and the crow can be an emblem of drunkenness because of its erratic, hopping gait.

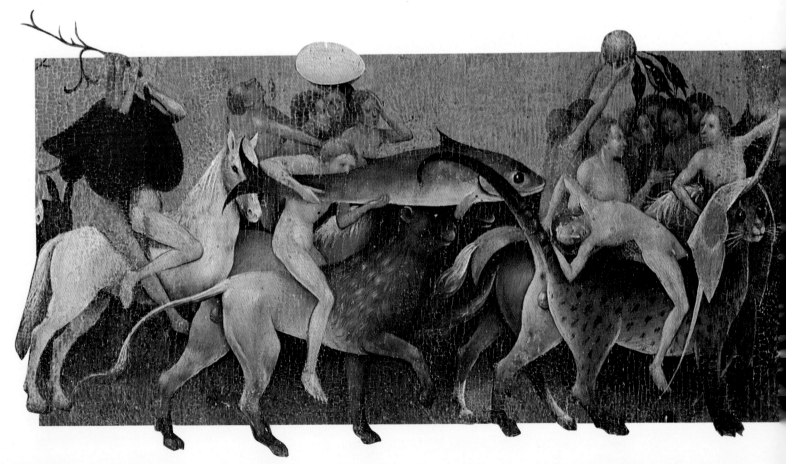

Prevailing Passions

A bird spears a man in the anus; this suggests that the man participates in "unnatural acts," such as sodomy, bestiality, and onanism, which in Bosch's day were roundly condemned by moral authorities as the most perverted of sexual transgressions. Another man contorts his body lasciviously while he rides, indicating that he too is guilty of some sort of erotic irregularity. The bear represents anger, and shows how violent acts stimulate lustful desires. Several men ride on donkeys, revealing their stupidity. Generally, the men are quarrelling, confused, and alarmed, all consequences of letting their animal passions run away with them.

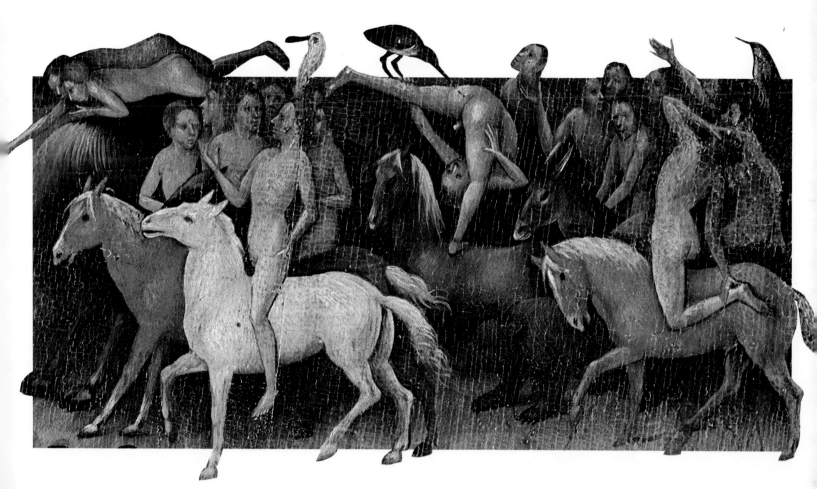

Moon Children

The children of Luna were thought to be inconstant, of a roving disposition, untruthful, irascible, and averse to any authority. Part of the ring of men and animals who circle the bathing women, these men are identified as moon children by the crescent moon that one of them holds. While seven brothers gaze, dazzled and spellbound, at the naked women, another looks curiously at the man with the moon. Does he practice the condemned arts of magic or astrology? Is he in league with Islam, whose crescent symbolized the Devil in medieval Europe? The curious man rides a unicorn, symbol of male sexuality because of its phallic horn.

False Flight

At the horizon of the Garden, humans climb to the pinnacles of the towers of Vanity and stretch their arms toward the sky. Sometimes they form a chain in their attempts to reach the heavens, often standing on their heads or dancing on the tip of a spire. Their dubious euphoria inevitably reminds one of those blissful LSD dervishes who waltzed out of windows on their way to India—or wherever God was at that instant—and fell to their deaths, into the unbelieving street, as Bosch's people are bound to fall through the floor of their medieval universe into perdition.

Those creatures who have actually managed to fly do so precariously, and usually in mixed company. The toad in the griffin's claws is traditionally one of Satan's favorite guises—the *Vaderboek* has him appearing to St. Anthony in the form of a toad with a human head. In hell, toads are both the tormentors and the diet of the damned, but Bosch employs the animal most often as an image of unchastity, notably in his painting *The Seven Deadly Sins*. The griffin and the red bird are also diabolic: the human who flies with their help will never know true soaring in heaven. The flying fish and berries remain sexual symbols in the sky, as on earth—their promised paradise is as illusory as that of Vanity or Power, and the fall from it just as certain and fatal.

At the right of the Garden panel, two figures with wings float dreamily in the air. One seems to be ascending with the help of a gleaming red balloon—or is it an errant cherry? These Boschian aviators recall the Greek myth of Icarus, who flew with the aid of artificial wings. The proud youth rashly soared too close to the sun, which melted the wax that anchored his wing feathers, plunging him into the sea.

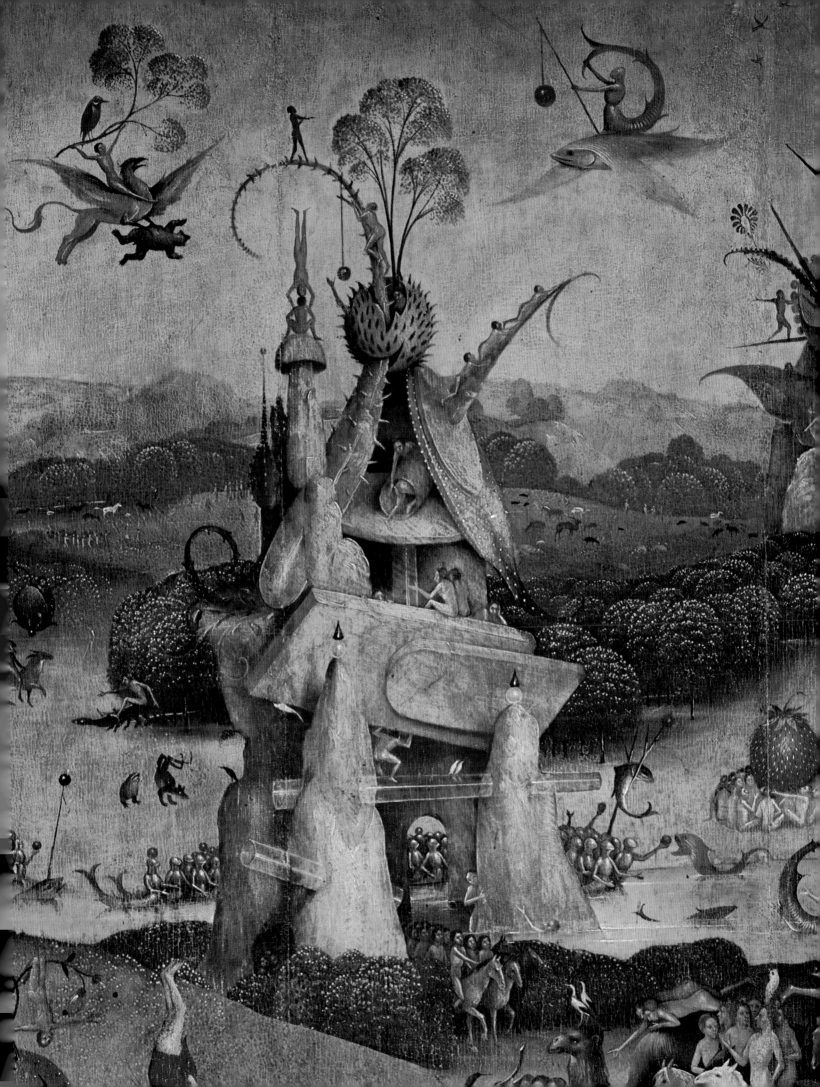

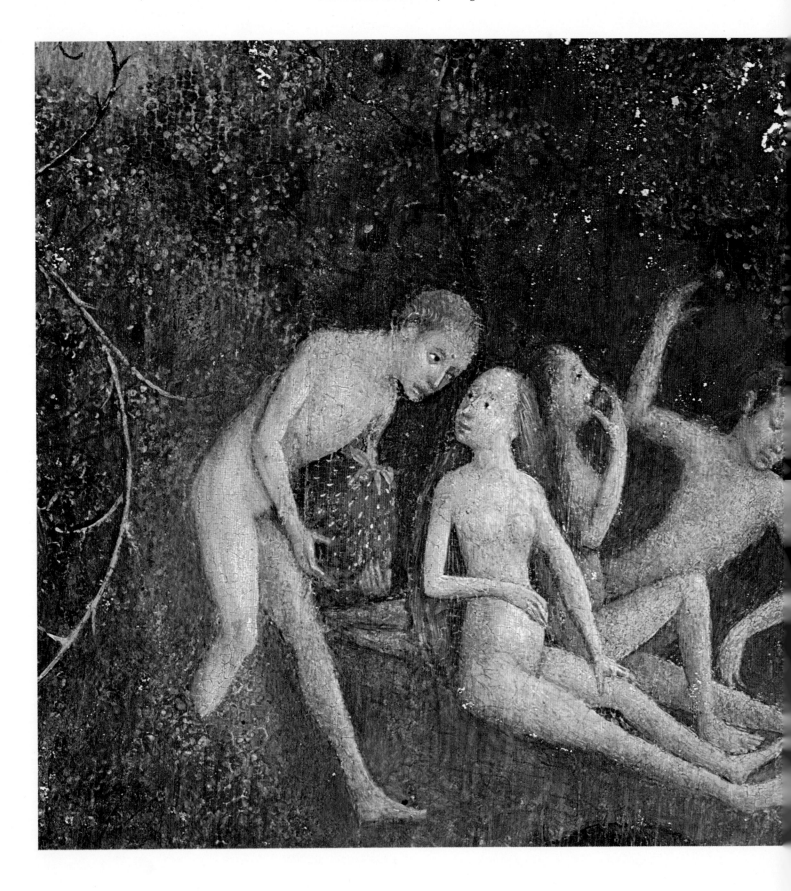

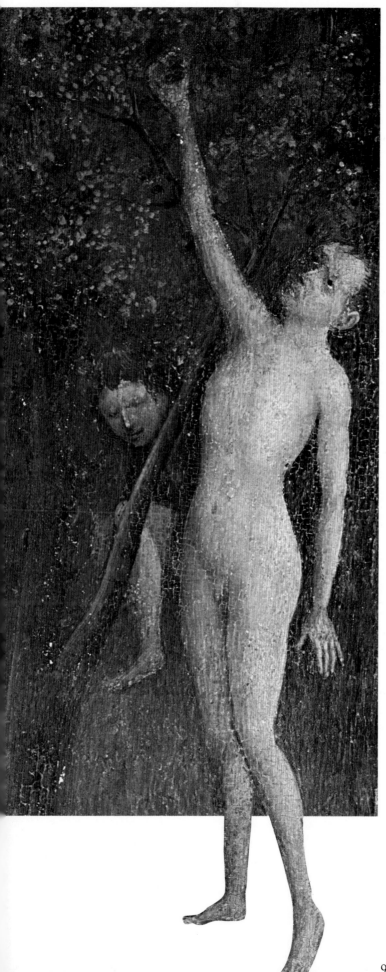

Wisdom Doesn't Grow on Trees

Naked dwellers in this earthly garden sport under a tree, plucking apples and blithely eating them, evoking the original sin of their forefathers (to which they seem utterly oblivious). One man invitingly offers a large strawberry to an Eve-like woman, who looks back at him with responsive innocence. Behind her, another woman smiles sensuously as she eats her apple. Three men show by their expressions that they have eaten the fruit to no avail: one continues to grope for knowledge with closed eyes; another broods in the shade of the tree, while a third looks surly and unhappy.

In his *Discours des sorciers* (1602), Henry Boguet expressed a long-standing belief when he wrote that demonic possession could be caused by eating apples, which were an appropriate hiding place for the Devil: "In this, Satan continually rehearses the means by which he tempted Adam and Eve in the earthly paradise." Boguet recounts that at Annecy in France in 1585 there was an apple that emitted a "great and confused noise. . . . It cannot be doubted that this apple was full of devils, and that a witch had been foiled in an attempt to give it to someone." The locals wisely tossed it in the river.

The Man Who Lost His Head

Not far away, a man whose head has already turned into a huge blueberry eagerly embraces a reclining woman. She looks at him with wary eyes, but her sensuous smile and exposed nipple tell us that she will give in to him—indeed, she may have bewitched him. The image of the pleasure-addicted berry-head is echoed in twentieth-century drug slang, such as "pothead" and "head shop."

O Brave New World

Dirk Bax suggests that the skin-clad couple may be Adam and Eve, emerging from the cave where apocryphal accounts have them taking refuge after their expulsion from Eden. Eve appears to be in a daze, still clutching the deadly apple which caused their fall. She is sheltered from this new world by the curved pane of glass, through which she gazes with a child's curiosity at the black bird, also encased in glass, who represents sin. It is as though she does not yet comprehend the meaning of what she has done, the relationship between the apple and the crow. Adam, his expression more grimly knowing, taps her on the shoulder, perhaps to awaken her from her false state of innocence. The man behind Adam is generally thought to be Noah, peering out into the world whose destruction he will witness and survive.

Another interpretation agrees that Bosch is showing Adam and Eve leaving their cave, but avers that, rather than being dressed in animal skins, the two are actually hairy. This would indicate a post-Eden transformation of Adam and Eve into wild man and wild woman—mythical beings with a long history in medieval art. Living in remote forests, caves and other places unfit for human habitation, the hirsute wild man personified unfettered animal forces, expressed through brutish violence, irrational moods, and sexual abandon. Bosch may have been suggesting that Adam and Eve were the progenitors of the monstrous, fabulous races of the world—including the wild man—or perhaps was merely using the wild man myth to illustrate the fall from grace of Adam and Eve. In any case, the behavior of the Garden's uninhibited nudes could well evoke the bestial nature of the wild man, as well as the sin of Adam and Eve.

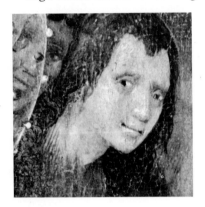

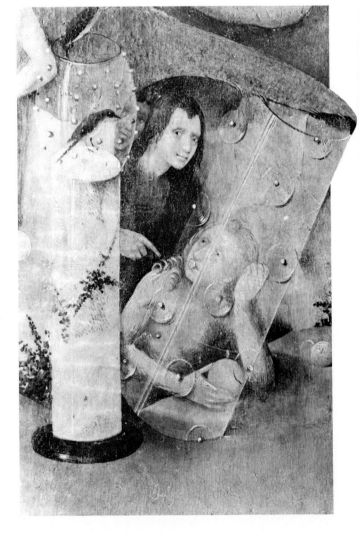

Love in Bloom

Happiness and glass,
how soon they pass...
Dutch proverb

Young lovers tenderly caress each other in the glass-like bulb of a flower, surrounded by a fine mist. The plant is filling their love chamber with heady vapors—probably an aphrodisiac perfume, redolent of desire. The lovers manifest fertile pollination—the "fructifying force" of nature. Bosch may be harking back to the mythical birth of Aphrodite, goddess of love (later known as Venus), who was believed to have been born of the foam of the sea.

Below the enraptured couple, a man enclosed in the plant's blossom beneath them looks into their future. He stares, mesmerized, at the black rat, symbol of both sexuality and disease. (It was the black "Alexandrine" rat that carried and spread the devastating bubonic plagues of the Middle Ages.) The lovers, still in the budding stage of their joy, would never believe that their bubble is soon to burst.

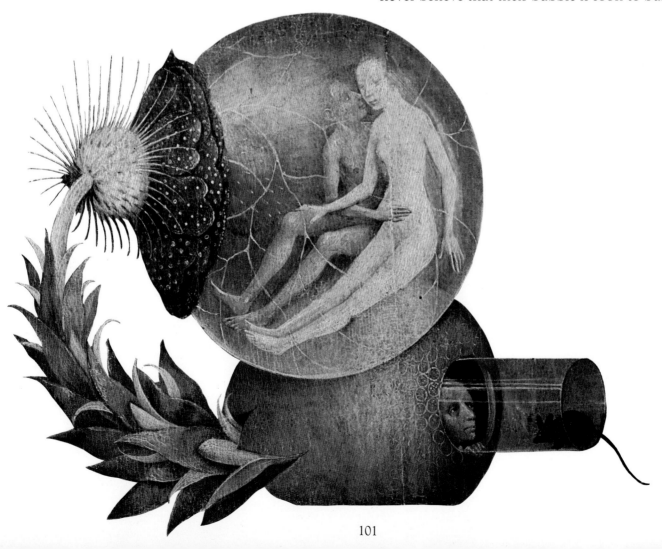

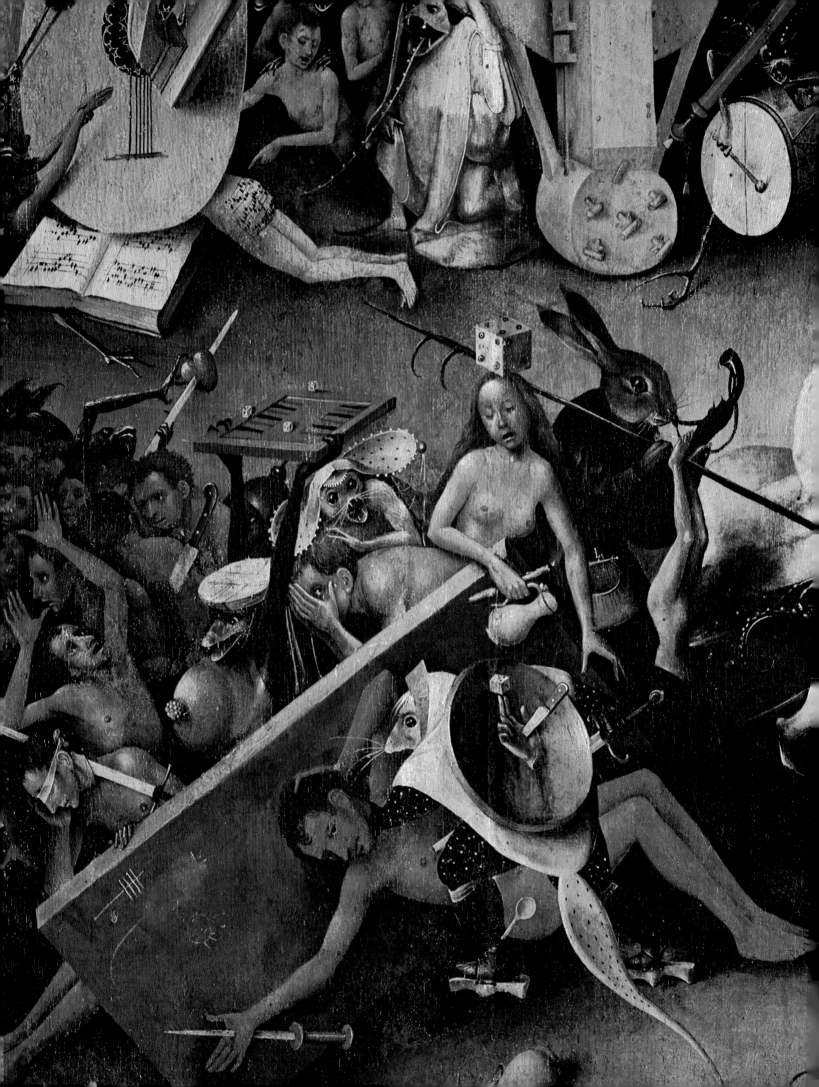

4
Demons and Damnation

Detail from
The Last Judgment (fragment).

Detail from
The Garden of Earthly Delights,
right panel.

Throughout the Middle Ages, fear was the best guarantee of virtue. The terrors of eternal damnation were vividly described by every preacher. Bosch expressed his own brand of apocalyptic pulpit oratory by painting the most frightening images of hell in human history.

This is exemplified in the right-hand panel of *The Garden of Earthly Delights,* in which the pursuit of sensation becomes in itself a form of punishment. In Bosch's hell, devils torment the damned with their former pleasures. We see minstrels tortured by the instruments they used to play, vain beauties forced to admire their reflections in a devil's ass, sodomists impaled by demon-birds, gluttons devoured by huge stomachs on legs.

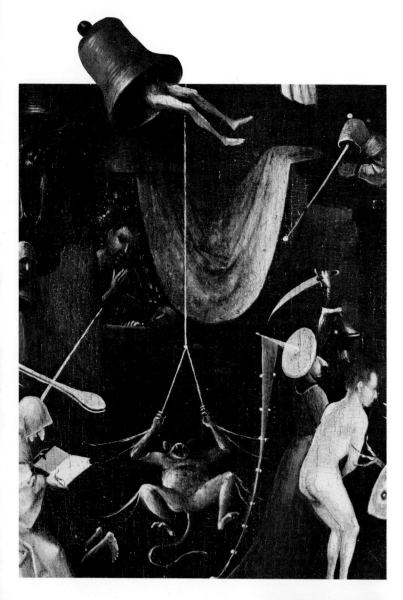

Details from
The Garden of Earthly Delights,
right panel.

In the Garden natural objects were oversized; in hell humans are dwarfed by common man-made articles, such as knives or chairs, and haunted by relics of their earthly vices—objects charged with ill repute, including dice and gameboards, a passkey, and lusty bagpipes. Bosch suggests that humans construct their own hells from the way they live their daily lives.

The damned are just as frenzied as the Garden's dwellers; but now, instead of rushing into erotic berry patches, they run from blazing fires or monstrous cleavers. Every pleasure they once enjoyed has been stood horribly on its head—even the dainty, ephemeral lovers' hideaways of the Garden are grotesquely mocked by the foul bubbles in which those swallowed by Satan are excreted. People who once frolicked in the Pond of Lust stand, blue-bodied and shivering, near its frozen counterpart in the center of hell.

To persecute the damned (and alert the living), Bosch created a contingent of demons that cause even sophisticated modern viewers to shudder. Many of them are hideous hybrids, part animal, part vegetable, part humanoid. Just as the Garden's humans sometimes resemble insects in their swarming pursuit of gratification, so the natives of hell may take insect form, with gauzy wings and fly faces. Indeed, the proverbial first demons were once rebel angels, expelled from heaven along with their defiant leader, Lucifer, and Bosch shows them changing into insects as they tumble headlong out of the sky.

Satan's emissaries plagued not only hell, but also the shadowy places of the earth, where they made life miserable for virtuous hermit saints like Bosch's favorite, Saint Anthony. Constantly mutating, taking on an endless succession of surreal guises, they could even assume the outward appearance of virtue, feigning a mother nursing a child, a knight riding a charger, a courtly lady giving alms. But their true nature is always apparent to the wise observer, revealing itself through telltale signs of evil—a deformed hand or foot, an inconspicuous badge of hell on their clothing, a bird of ill omen lurking nearby.

Bosch's fiends were unsurpassed at summoning up the diabolical fantasies that haunted the medieval mind, playing on the widespread dread of evil and the Prince of Darkness. These demons are both centuries old and ageless. Undaunted by modern times, they remain quite capable of preying on the imagination.

The First Damnation

Satan was first known as Lucifer, an upstart angel with divine aspirations. He attempted a *coup d'état* of the highest order, but his forces were defeated in a fierce conflict with the heavenly hosts. Banished from heaven, Satan continued waging war, with earth as the battleground.

Here, the rebel angels are hurled down from celestial bliss toward the depths of hell. They scramble in the firmament, yearning desperately for the least foothold in God's grace, but they are doomed to fall. As they do, a strange transformation takes place: gracefully arched angel wings turn into dragonfly wings, moth wings, even cockroach wings. They tumble crazily to earth, suddenly susceptible to the pull of gravity.

Details from
The Garden of Earthly Delights,
right panel.

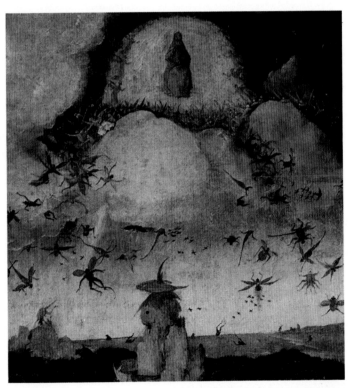

Detail from *The Haywain,* left panel.

When Hell Freezes Over

*There are sorrowfully mixed together the
smoky flame and the violence of cold ice,
very hot and cold in the midst of hell.*
Homilies of Wulfstan (Eleventh Century)

"The world goes on skates" was a common Netherlandish proverb of Bosch's time, meaning that the world slides and skids helplessly toward wickedness. Another expression ran, "Cracked ice, bad ice." Here the damned try to skate through a hell that owes more to the frigid afterworld of Norse mythology than it does to proper Christian flames, but they are doomed to encounter treacherous ice. All around them other damned souls flounder and freeze, only their heads above hell's foul waters.

Hear No Evil

" . . . there is no vice that will not receive its proper retribution."
Thomas à Kempis, *Imitation of Christ*

If there is a single key to Bosch's boundlessly complex visionary language, it lies, paradoxically, in its literalness. In his Inferno, the Seven Deadly Sins are punished with a by-the-book precision that looks chaotic only to those not born to the certainty that the vain will be tormented by their own images, the glutton vomit eternally, the miser be compelled to defecate his gold in a double agony of covetousness and constipation.

Following the same line of dreadful logic, it would seem that these monstrous human ears, which instantly remind us of hell's cacophony, are crushing and slicing up those who have blasphemed, lied, borne false witness; perhaps even played frivolous or sacrilegious music on the very instruments that now assail their senses. A musician himself, Bosch proba-bly shared the medieval ambivalence toward this most seductive of arts, considered capable of serving God in one measure and the Devil in the next, without ever belonging to either camp. (It is oddly haunting to realize that there isn't a single musical instrument to be seen in the Garden of Earthly Delights; and yet of course there is music there, piping, entwining, sometimes murmurously distant, sometimes near and terribly shrill. One has only to look at the painting to hear it.)

This grisly hybrid device resembles an awful engine of war, in keeping with the scenes of devastation in the background. It also recalls an image favored by medieval moralists such as Richard Rolle, who wrote in *The Pricke of Conscience* (1340): "As a warlike machine strikes the walls of a city, so shall devils strike the souls and bodies of the wicked."

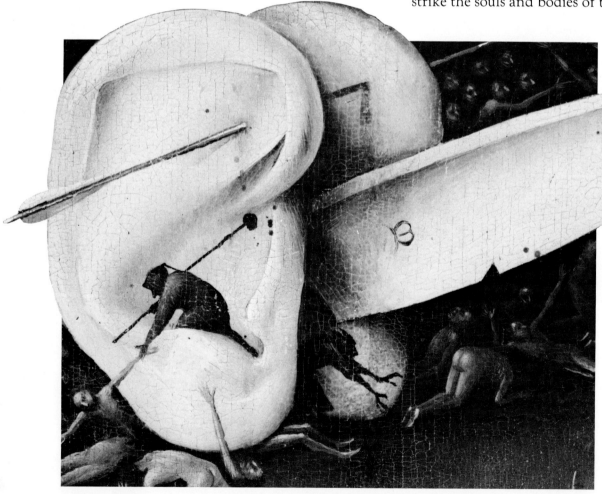

Details from
The Garden of Earthly Delights,
right panel.

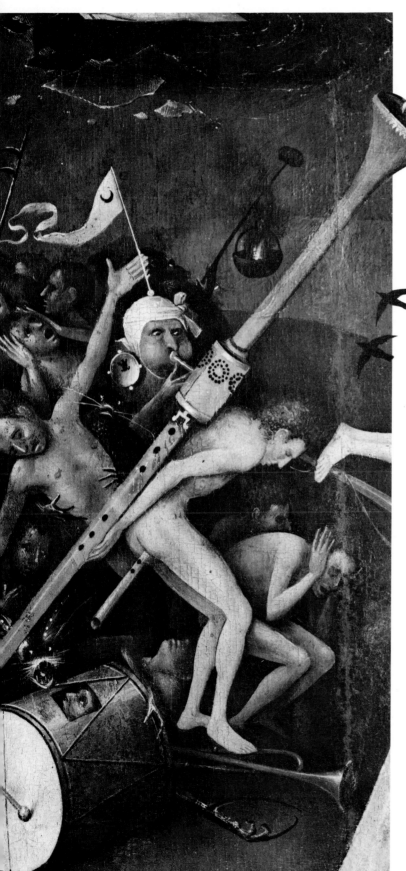

High-Decibel Horror

In life these men filled their ears with music; in hell they fill musical instruments, or have their ears and bodies pierced by them. Sinners cover their ears in a desperate, futile attempt to muffle the incessant clamor. It is a demonic symphony scored for blaring trumpets, bleating woodwinds, rasping strings, and a groaning giant of a hurdy-gurdy. One man is trapped in a drum being pounded by a demon. Another, who carries a huge bassoon-like instrument in a posture meant to suggest Christ shouldering his crucifix, is cruelly accompanied by a flute sticking up his hindquarters. A red-faced fiend inflicts reverberating pain with each dissonant note he plays (if dissonance has any meaning in a world where it is the rule, not the exception). He wears a flag on his cap which the damned observe with horrified understanding. It bears the image of the crescent moon, emblem of the infidel East, the same symbol carried by a rider in the Garden. One implication may be that these damned practiced such arts as astrology or alchemy during their lives—perhaps without ever knowing that they were actually serving Satan.

Harp of Torture

In heaven angels play beautiful melodies on golden harps; in Bosch's hell the gentle harp becomes a fearsome instrument of torture. A sinner suffers excruciating pain, his body pierced by the taut strings of the instrument through some diabolical hex. A black snake writhes around the frame of the harp and bites the unfortunate man on the hip. Nearby, two demons adjust the body of a man in an uncomfortable position atop a giant lute, before a frightened crowd of onlookers. In life they may have been dissolute minstrels who played music for wanton merrymakers.

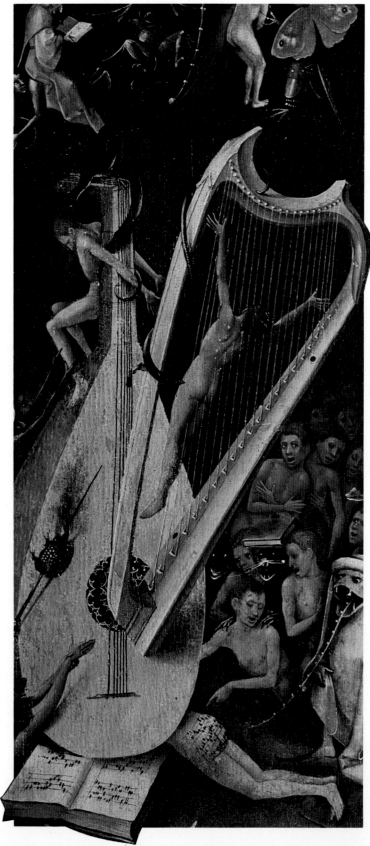

Chorus of Despair

Conducted by a hideous fanged frog-demon, a terrorized group of choristers are forced to read hellish music (with notes like thorns or drops of blood) imprinted on a man's buttocks. Their anguish and desperation is pitifully apparent, as they struggle to sing a dirge of their damnation. One sufferer, crushed beneath the enormous music book and lute, is forced by a devil to point to the man impaled on the harp-strings. He is pointing, of course, for the viewer's edification.

Details from
The Garden of Earthly Delights,
right panel.

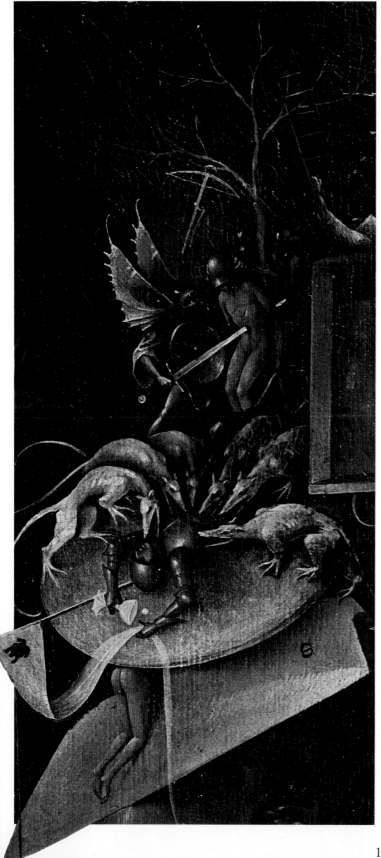

Infernal Soldiers of Fortune

'Soldier' originally meant a hireling or mercenary; one paid a (Roman) solidus for military service
E. Cobham Brewer

He wants to visit the fair,
He thinks that he's a landgrave;
He wants to smash down everything there
With his rusty stave.
Of the wine he then starts drinking,
Gets sozzled as soon as it's down;
Then the world is his to his thinking—
The city, the land and the town.

This verse, written by a horse-soldier of Bosch's time, expresses the attitude for which these mercenaries are being punished in hell. One of the curses of the late Middle Ages were roving bands of "hired swords"—the original free-lancers. These were plundering bravos who sacked cities and robbed, raped and terrified the townspeople. Here a troop of such brigands is attacked in its turn by demon-guerillas. Many of the soldiers are naked except for their helmets, implying they have led debauched lives under the guise of patriotic fighting. The soldier whom the hellhounds are gnawing clutches a golden chalice, showing that he was both a heavy drinker and a pillager of churches. The chalice and coin were attributes of Lady Fortune, who ruled perversely over the luck of mercenaries, often "turning the tables" on her favorites. Ironically, the troop's standard bears an image of a toad—a sign of the Devil.

Venomous Toad

Each darling sin will find its appropriate reward; for the proud, every kind of humiliation, for the covetous, the pinch of grinding poverty. Spend a hundred years of penance here on earth, it would be no match for one hour of that punishment. Here we have intervals of rest, and our friends can comfort us; there is no respite for the damned, no consolation for the damned.

Thomas à Kempis, *Imitation of Christ*

Details from
The Garden of Earthly Delights,
right panel.

A young woman resembling many of the Garden's beauties slumps numbly at the foot of the devil's chair. A repulsive toad clings to her chest. The toad was regarded as a sign of the Devil and witchcraft, and was widely thought to be poisonous. Fallen into a stupor due to the effect of its venom, the woman has become the object of the attentions of a nearby demon, who slyly embraces her with spindly tentacles. Their images are reflected in a convex mirror embedded in the backside of a kneeling tree monster. The mirror signifies that her sin was vain self-admiration, as the demon claws grotesquely mock the hands that caressed her on earth.

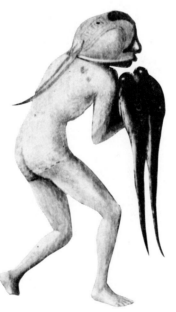

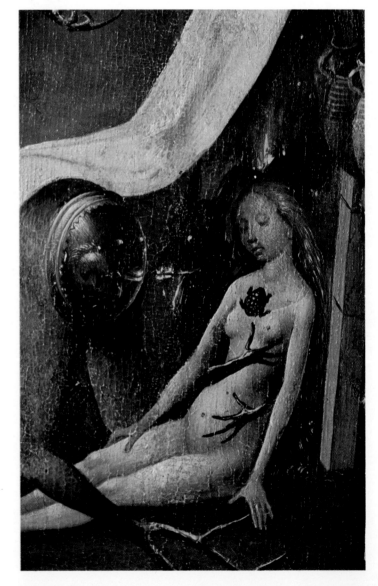

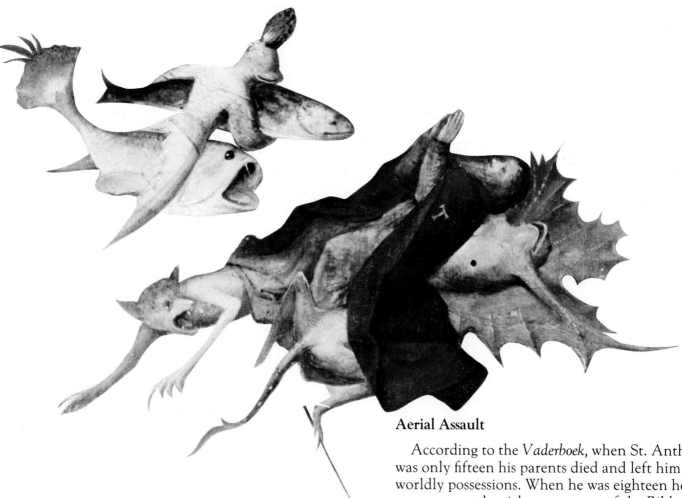

Details from
The Temptation of St. Anthony,
center panel.

Aerial Assault

According to the *Vaderboek*, when St. Anthony was only fifteen his parents died and left him all their worldly possessions. When he was eighteen he heard a sermon on the rich young man of the Bible which so moved him that he became a monk, gave his money away, and retired to a cave in the wilderness where he lived on nothing but bread. There he meditated and worshiped God throughout the day.

Satan, hearing of this virtuous man, sent his demons to torture him. They appeared to St. Anthony in the form of wild beasts: a winged toad, an ape and a dog-like creature. They dragged him from his cave, taunting and beating him, and finally bore him into the sky where he became an unwilling participant in a diabolical dogfight.

As Anthony soars through the air on the belly of a huge winged toad, a devil-knight on a malevolent fish charger brandishes a cod as a weapon. A hellhound shrieks with joy as he flails at the pious hermit with a leafy branch, while a naked boy sails by in a flying boat, leering upside-down from between his legs. Anthony prays desperately for divine aid to help him resist these frightful assaults. The *T* embroidered on his monk's habit stands for "Tau," the first letter of the Greek word "Theos," meaning God.

Crafty Plotters

Having barely survived the torments of his fiendish sky-ride, the exhausted St. Anthony is carried back to his cave by two fellow monks and a layman friend (possibly Bosch himself). They assist him across a narrow wooden bridge—always a symbol of new trials and temptations. Wily demons lurk furtively underneath the footbridge, while a treacherous devil-messenger with long floppy ears skates by, a letter attached to his beak. The message refers, no doubt, to a plot being hatched to trap the virtuous saint. On the nearby bank a chick emerges ominously from the shell of a monstrous egg. An artist who shared the Reformation distrust of the papacy, Bosch gives the demon beneath the bridge wearing a priest's skullcap the jowly features of the notorious Borgia pope, Alexander VI (1492–1503), whose rule was marked by vice and corruption. Many thought that Alexander was the Antichrist, the dreaded evil counterfeit of Christ who was expected to appear at the end of the world. This identification may be supported by the letter A on the messenger's badge, as well as by the deceptive mirror-writing on the proclamation read by the devil–pope.

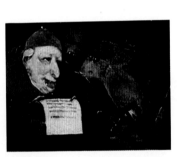

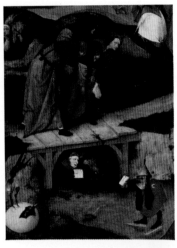

Details from
The Temptation of St. Anthony,
left panel.

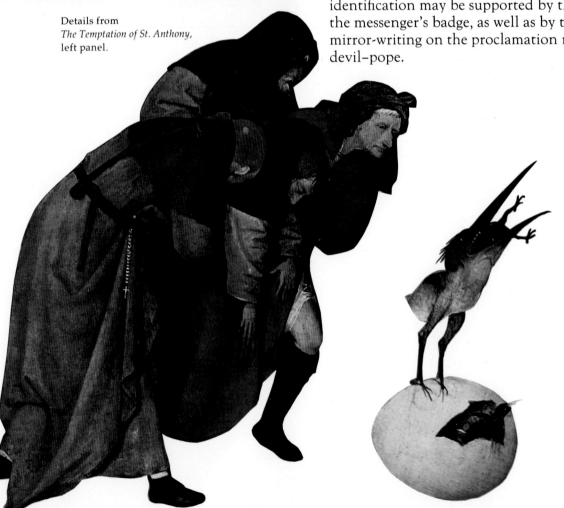

The Man-Cave

The Devil's ass is hell's gateway.
Medieval Dutch saying

St. Anthony's friends carry him to his cave, usually a holy refuge of peace. But devils have taken over his cave, turning it into a brothel-tavern made of a giant's body. Bedeviled and bent over on all fours, the giant signifies the fate of the dissolute tavern haunter. A barmaid scans the countryside from a window in a way that unmistakably reveals her second trade. Walking ahead of Anthony and his friends, a demon-bishop with a telltale deformed hand leads mock clerics on to drink and adultery.

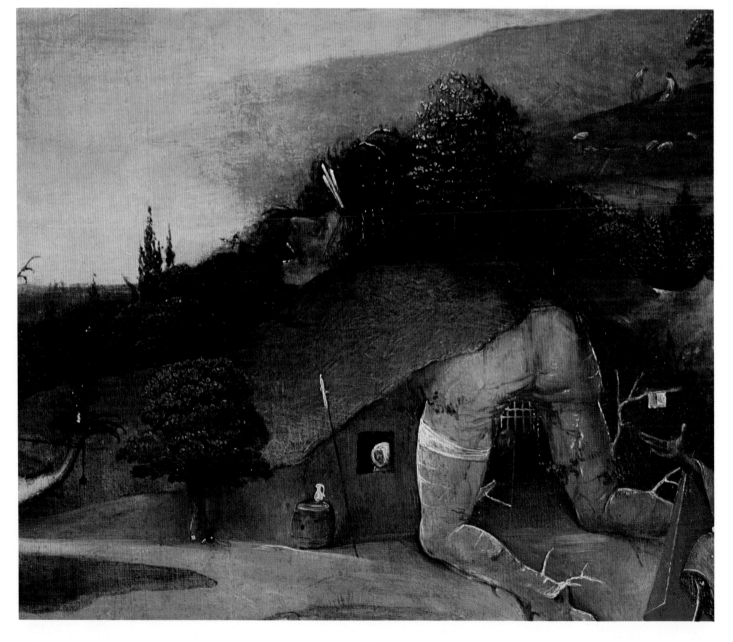

The Devil-Queen

For just as the exhalations of the earth form themselves into clouds which, when shaken by the winds, take an infinite variety of shapes; so also do the Demons, by means of their fluency and rapid dexterity, shape their bodies from a concrete condensation of air and vapours into whatever form they desire. . . . Now they will confine themselves within the very smallest of bodies, and now dilate themselves into monstrous size; sometimes they appear as men, sometimes as women; they will roar like lions, or leap like panthers, or bark like dogs; and at times will transform themselves into the shape of a wine-skin or some other vessel.

Nicholas Remy, *Demonolatry* (1595)

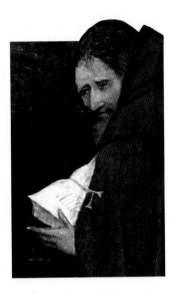

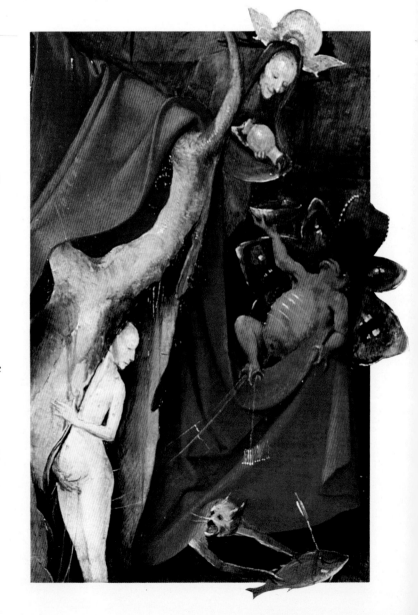

Several years later, according to the *Vaderboek*, St. Anthony, wandering in the wilderness, came upon a beautiful queen bathing with her court ladies. The saint's modesty was shocked, but she dressed quickly and begged him to come with her to her kingdom, to teach her the way of beatitude. He agreed, and soon found himself in a kingdom of unparalleled wealth and beauty, full of treasures and alluring maidens. The queen claimed that God had given her all this as a reward for her great charity. To demonstrate her heavenly powers, she had the diseased and crippled of the kingdom brought before her. As St. Anthony looked on, she cured them all with a sweep of her hand.

The queen desired Anthony for her husband. He was sorely tempted, but refused. Still she persisted, employing all of her wiles to seduce him. At last he realized that she was the Devil and called on Christ to help him. No sooner had he cried out than the queen changed into a large black pig, belching smoke and a foul stench. Her knights and maidens turned to devils, seized Anthony and dragged him through the streets of the city.

Bosch's devil-queen appears to St. Anthony as a sensuous nude bather standing enticingly in the cleft of a hollow tree. The saint anxiously averts his eyes from her sight. Just behind the tree, an old procuress pours a love potion into a cup held by a jovial demon-toad.

Table of Tosspots

St. Anthony turns away from the devil-queen, only to be mocked and tempted by drunken carousers gathered by a round table. The man blowing a curving trumpet was a minstrel. His instrument was called a *trompe*, which means deceit (the French verb remains *tromper*), and also a *claret*, a dry red wine. The minstrel, then, is a dishonest tippler. His drinking companion reels sottishly on a crutch, one foot stuck in a large wine pot. A third naked man—a roving mercenary, judging from his drawn sword and gauntlet—lies passed out under the table. His throat is being slit by a grinning demon cat. The jug with a pig's trotter on the table is a sign of drunken excess. To the right of the table is a *buikbeest* (belly-beast), a foolish, guzzling glutton whose stomach has taken over his head and body.

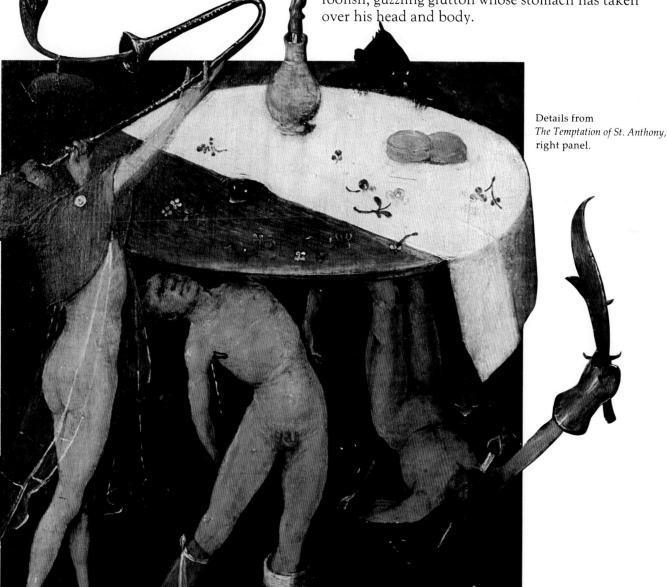

Details from
The Temptation of St. Anthony,
right panel.

Charitable Demons

They trail behind them long tails
Like serpents, four ells in length
They'd rather have beasts' semblance
Than to wear the human aspect.
<div align="right">Unknown Dutch Poet</div>

Details from
The Temptation of St. Anthony,
center panel.

In Bosch's diabolical bread line, beggars gather around St. Anthony to receive free food and drink from three richly dressed individuals. The outlandish costumes of the almsgivers cast doubts on the motives behind their charity, which is meant to deceive the saint. The train of one woman's dress looks alarmingly like a reptile's tail, while the tasselled headdress of the person on her left resembles Medusa's fabled mane of serpents. Just beyond is a woman who appears to have turned into stone, like the victims of the treacherous Medusa; she wears an equally bizarre bonnet sprouting thorns, which could represent sins. A black servant brings forth a platter on which squats a repulsive toad holding up a large egg—rotten, no doubt, like their devilish philanthropy. St. Anthony looks at us appealingly and raises two fingers, as if to ward off the evil that surrounds him.

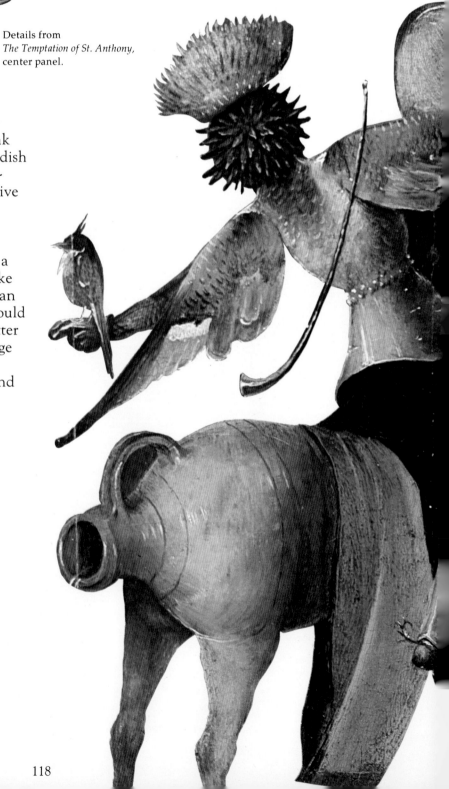

Beggar Family

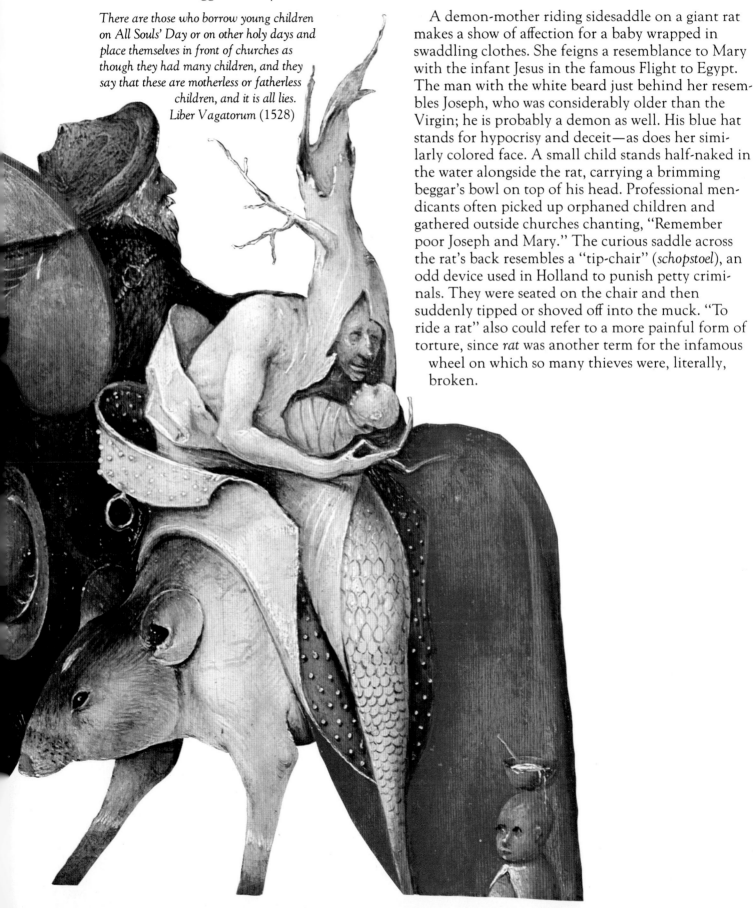

There are those who borrow young children on All Souls' Day or on other holy days and place themselves in front of churches as though they had many children, and they say that these are motherless or fatherless children, and it is all lies.
Liber Vagatorum (1528)

A demon-mother riding sidesaddle on a giant rat makes a show of affection for a baby wrapped in swaddling clothes. She feigns a resemblance to Mary with the infant Jesus in the famous Flight to Egypt. The man with the white beard just behind her resembles Joseph, who was considerably older than the Virgin; he is probably a demon as well. His blue hat stands for hypocrisy and deceit—as does her similarly colored face. A small child stands half-naked in the water alongside the rat, carrying a brimming beggar's bowl on top of his head. Professional mendicants often picked up orphaned children and gathered outside churches chanting, "Remember poor Joseph and Mary." The curious saddle across the rat's back resembles a "tip-chair" (*schopstoel*), an odd device used in Holland to punish petty criminals. They were seated on the chair and then suddenly tipped or shoved off into the muck. "To ride a rat" also could refer to a more painful form of torture, since *rat* was another term for the infamous wheel on which so many thieves were, literally, broken.

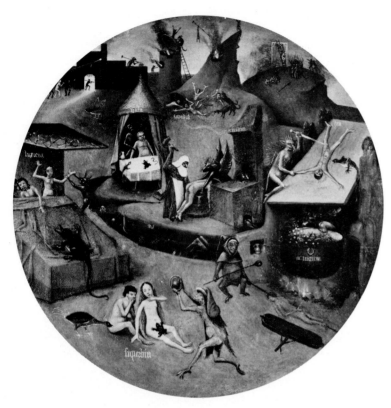

Detail from
The Seven Deadly Sins.

Fish in Troubled Waters

I trust, young man, that neither idleness nor licentious pleasure, . . . the chief baits with which the great Fisher of Souls conceals his hooks, are the causes of your declining the career to which I would incite you.
Sir Walter Scott, *The Monastery*

Detail from
The Haywain, right panel.

Those fires, what is it they will feed on but your sins? The more you spare yourself, and take corrupt nature for your guide, the heavier price you will pay later on, the more fuel you are storing up for those fires. The pattern of a man's sins will be the pattern of his punishment; red-hot goads to spur on the idle, cruel hunger and thirst to torment the glutton; see where the dissipated souls, that so loved their own pleasures, are bathed in hot pitch and reeking sulphur, where the envious souls go howling like mad dogs, for very grief!
Thomas à Kempis, *Imitation of Christ*

No Rest for the Wicked

Contained within a circle on Bosch's tabletop painting *The Seven Deadly Sins* is a gang of demons appropriately punishing former practitioners of these sins. A devil waving a mirror torments a once-vain couple; a man and woman confined to bed for their boundless lust are assailed by lascivious fiends. The avaricious simmer eternally in a cauldron of coins, near a spread-eagled victim of his own anger, who has fallen prey to hell's fury. Held captive in a tent, the former glutton now must suffer a diet of toads, snakes, and the like. A man guilty of sloth is energetically hammered on an anvil, while sinners in the background are attacked by dogs who symbolize their earthly envy.

"The big fish eat the little ones," goes the saying, and here a ravenous fish-devil punishes a gluttonous human. Just as the fish-devil's stomach and mouth have swallowed up the rest of his body, so he swallows the sinner's body up to the legs. The serpent entwined about the sinner's legs is the same one who lured Eve to her fatal gluttony. Now he gnaws at the man's genitals, a reference to Adam and Eve's companion sin of lust.

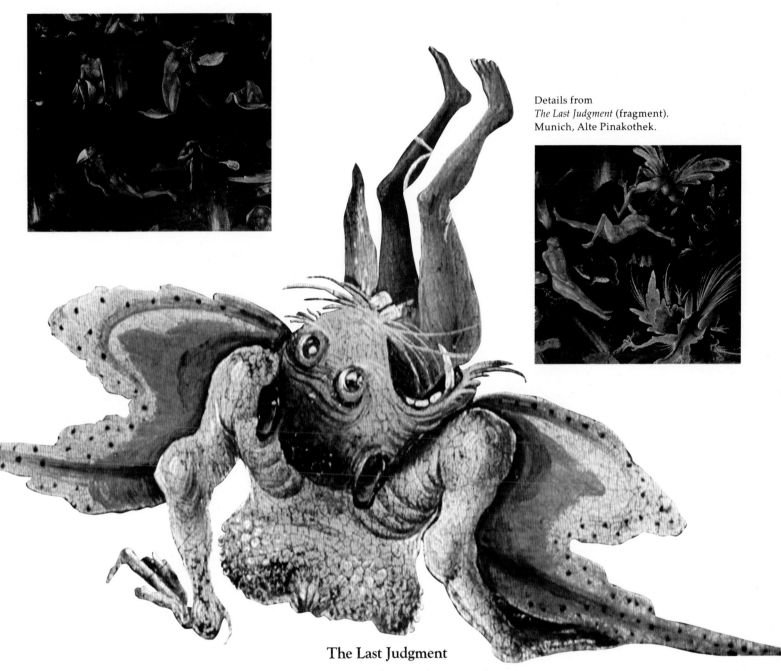

Details from
The Last Judgment (fragment).
Munich, Alte Pinakothek.

The Last Judgment

It is impossible to speculate with any real confidence on this damaged fragment of an altarpiece; but it may represent a vision of the Last Judgment which holds that resurrected sinners (Bosch is careful to include heads of church and state) will turn into half-human, half-insect creatures who will prey on other sinners until they too change into the same horridly graceful hybrid form. Soon what remains of the earth will be aswarm with insect-demons devouring one another. The terror of this apocalyptic scenario is belied by the deceptive, translucent beauty of these winged devils.

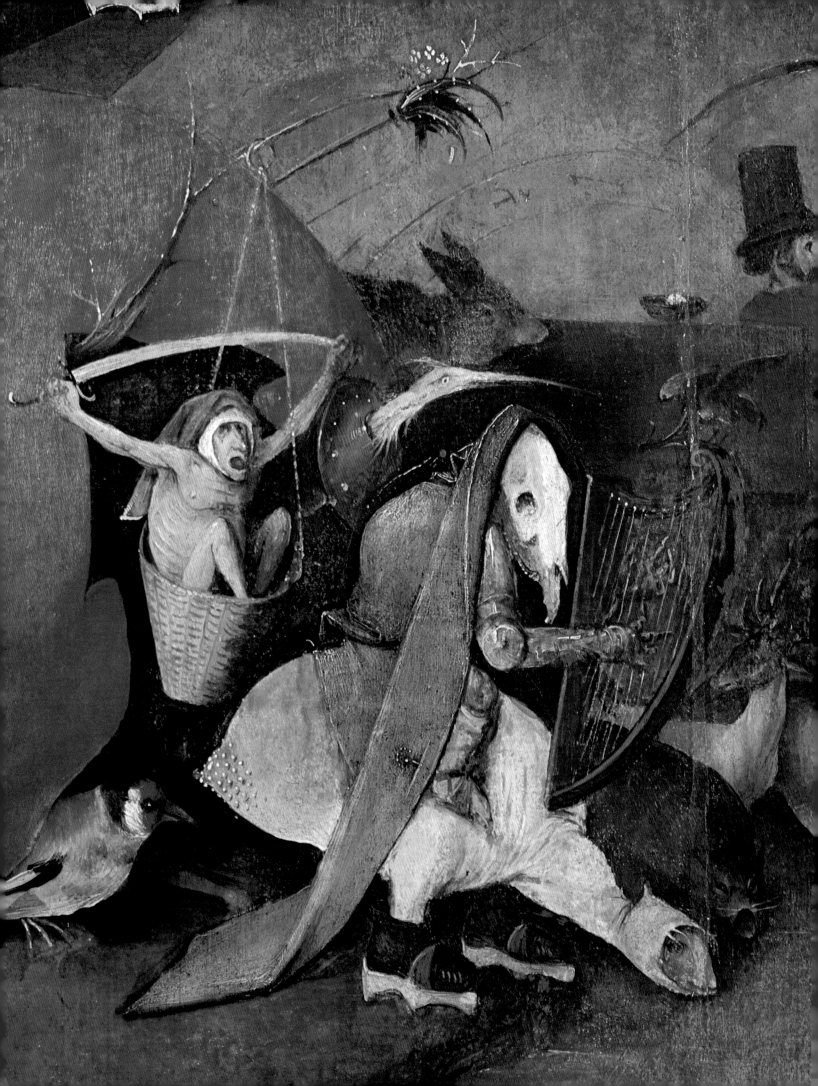

Epilogue

So violent and noisy was life, that it bore the mixed smell of blood and of roses. The men of that time always oscillate between the fear of hell and the most naive joy, between cruelty and tenderness, between harsh asceticism and insane attachment to the delights of this world, between hatred and goodness, always running to extremes.

Johan Huizinga

Bosch's most typical paintings abound with beautiful, ethereal people and superbly hideous, uncomfortably *tangible* demons. Nature is huge and over-generous in the Garden of Earthly Delights, but readily contorts into a nightmare in hell. Likewise, the sensual pleasure of eating or making love twists into pain when humans are overmastered by their desires. Everywhere in the paintings, wild hungers drive men and women to thoughtless, self-destructive action. These drives are the Devil in us, Bosch seems to say. His demons are grimly obsessive, desperate to inflict pain, able to feed only on human suffering. Thus we are warned: behind beauty lurks corruption; behind joy, despair; behind pleasure, eternal torment.

The human being is the contradictory animal, as uniquely able in today's world as in Hieronymus Bosch's to juggle within a single skull any number of equally cherished, absolutely opposed ideas, value systems, modes of behavior and simple daily habits, and still somehow function—after a fashion. In medieval Europe, people used to gather at the summons of a famous preacher and excitedly burn all their "sinful" possessions—cards, finery, musical instruments. In the Hell panel of *The Garden of Earthly Delights* we see a similar kind of sacrifice: a table covered with game boards, dice, a mandolin and a wine jug is overturned and set on fire. Penitents paraded through the streets, flogging themselves for their transgressions with the same enthusiasm with which they would have beaten and stoned a witch, a heretic, or some other chosen scapegoat. Public executions were at once monstrously cruel events,

matching anything to be seen in Bosch's hell, and profoundly sentimental theater, in which a criminal could move his audience and his executioners to hysterical tears with a speech from the scaffold. In every likelihood, the tears were as real as the dangling body that closed the show.

Bosch *is* his fifteenth-century world; and if he reflects its terrors and its moral dilemmas, he gives us its wit just as faithfully. The hedonist with a berry-head, the jester about to be spanked with a spoon, bizarre fish-knights rushing to embrace mermaids, faithless flimflam healers, reeling wastrels, gluttons consumed by their stomachs: such are the riches of an often uproarious visual vocabulary. On much more than a technical level, Bosch's art is a monument to his genius at manipulating the tension between humor and horror, grotesqueness and delicacy, the impossible and the everyday. It is this constant play of opposites that at once places his work in time and makes it timeless.

That Bosch himself encompassed these contradictions ensures that he will remain an enigma. A seasoned understanding of the delights of this world is everywhere evident in his work. If the beauty he creates strikes us at times as frightening or disquieting, if its purpose seems only to moralize with insane severity—even so, there is also, always, a tenderness that heightens the sensuality as well as the dreadfulness. No one could have preached so powerfully against the entrapments of the earth and its joys who was not himself forever moved and tempted by them. It may all indeed be illusion, Satan's lure; but like Bosch's figures—like Bosch himself?—we can't help being taken in.

Detail from
The Temptation of St. Anthony,
center panel.

Bibliography

Baldass, Ludwig von. *Hieronymus Bosch*. New York, 1960.
A solid scholarly study of Bosch's work, with an
emphasis on connoisseurship.

Bax, Dirk. *Hieronymus Bosch: His Picture-Writing Deciphered*,
translated by M.A. Bax-Botha. Rotterdam, 1979. A
heroic attempt to interpret Bosch's *Temptation of St.
Anthony* and other paintings in terms of Netherlandish
folklore and proverbs.

Bergman, Madeleine. *Hieronymus Bosch and Alchemy: A Study
on the St. Anthony Triptych*. Stockholm, 1979. A
recent interpretation of the alchemical symbolism of
The Temptation of St. Anthony.

Cinotti, Mia. *The Complete Paintings of Bosch*. New York,
1969. A convenient *catalogue raisonné* of Bosch's
work, fully illustrated.

Combe, Jacques. *Hieronymus Bosch*. London, 1947. An
imaginative study of Bosch, with much information
on alchemy.

Cuttler, Charles D. *Northern Painting: From Pucelle to
Bruegel*. New York, 1968. Standard text on northern
Renaissance painting, including a scholarly intro-
duction to Bosch's work.

Fraenger, Wilhelm. *The Millenium of Hieronymus Bosch*.
London, 1952. A controversial, highly influential
interpretation of *The Garden of Earthly Delights*,
relating it to the heretical Adamite cult.

Gibson, Walter S. *Hieronymus Bosch*. New York, 1973.
A very good analysis of Bosch's art for the general
reader.

Huizinga, Johan. *The Waning of the Middle Ages*. New York,
1954. A monumental study of the art and culture of
the late Middle Ages, essential for understanding the
mentality of Bosch's era.

Marijnissen, R.-H., and Seidel, M. *Hieronymus Bosch*.
Brussels, 1972. A recent team study (in French) of
critical problems, relevant documents, connoisseurship,
and iconography.

Panofsky, Erwin. *Early Netherlandish Painting* (2 volumes).
New York, 1971. Best general study of early Netherlandish
painting, including limited observations on Bosch.

Philip, Lotte Brand. *Hieronymus Bosch*. New York, 1955.
Selected illustrations from Bosch's art, accompanied
by stimulating observations.

Snyder, James. *Bosch in Perspective*. Englewood Cliffs, 1973.
A compendium of source material and outstanding
articles on the artist, together with a provocative
introduction.

Solier, René de, and Orienti, Sandra. *Hieronymus Bosch*.
New York, 1976. A general survey of interpretations
of Bosch's art.

Tolnay, Charles de. *Hieronymus Bosch*. New York, 1966.
Perhaps the most comprehensive and well-illustrated
study of the artist, including a *catalogue raisonné*.

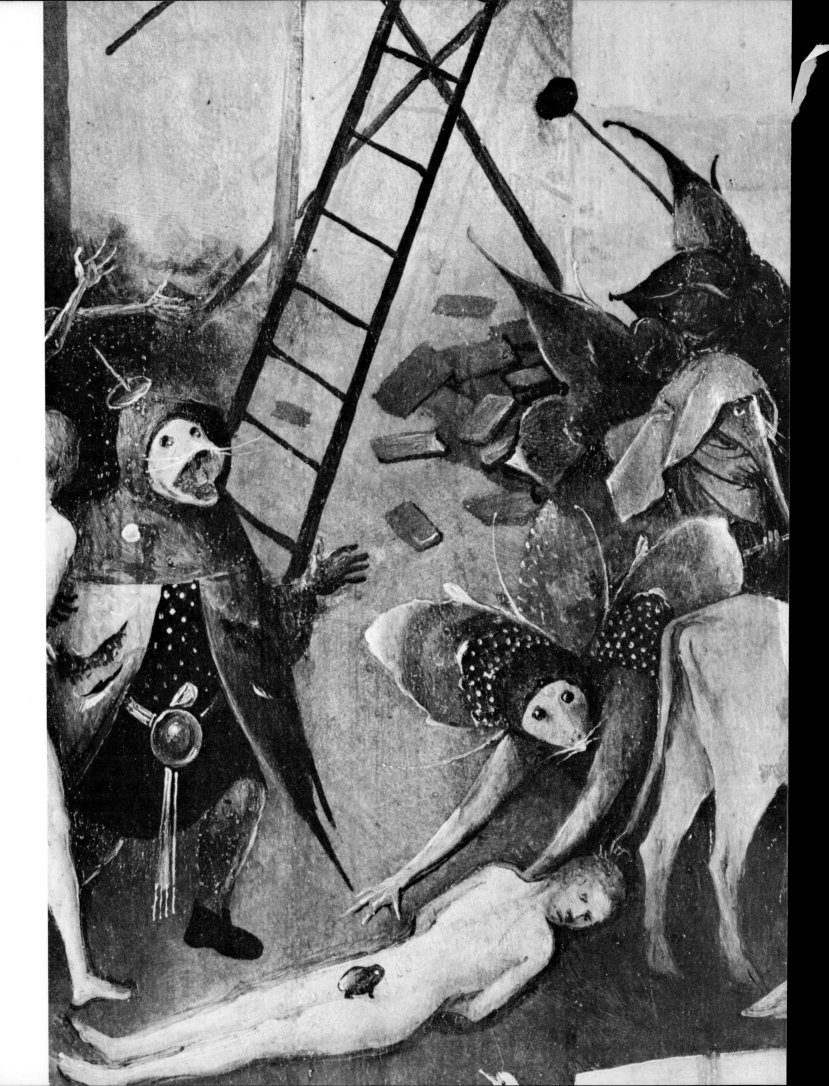

List of Paintings

Allegory of Gluttony and Lust (fragment). New Haven, Yale University Art Gallery.

Christ Carrying the Cross. Ghent, Museum voor Schone Kunsten.

The Conjuror. Saint-Germain-en-Laye, Musée Municipale.

The Cure of Folly. Madrid, Museo del Prado.

The Garden of Earthly Delights. Madrid, Museo del Prado.

The Haywain. Madrid, Museo del Prado.

The Last Judgment (fragment). Munich, Alte Pinakothek.

The Seven Deadly Sins. Madrid, Museo del Prado.

The Ship of Fools. Paris, Musée du Louvre.

The Temptation of St. Anthony. Lisbon, Museu Nacional de Arte Antiga.

The Wayfarer. Rotterdam, Museum Boymans–van Beuningen.

Detail from
The Haywain, right panel.

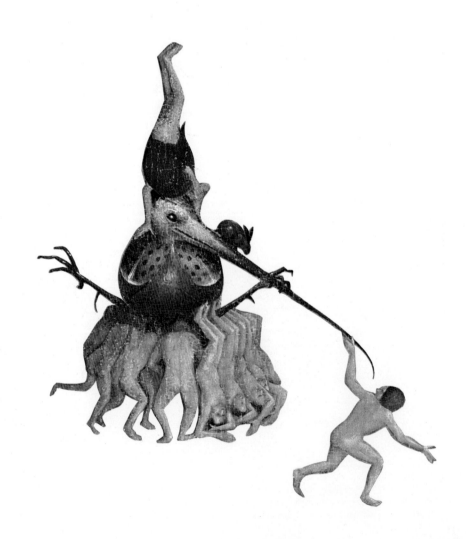